SECRET YORKSHIRE DALES

Mike Appleton

AMBERLEY

First published 2021

Amberley Publishing
The Hill, Stroud
Gloucestershire, GL5 4EP

www.amberley-books.com

Copyright © Mike Appleton, 2021

The right of Mike Appleton to be identified as the
Author of this work has been asserted in accordance
with the Copyrights, Designs and Patents Act 1988.

ISBN 978 1 4456 9159 6 (print)
ISBN 978 1 4456 9160 2 (ebook)

British Library Cataloguing in Publication Data.
A catalogue record for this book is available from the
British Library.

Origination by Amberley Publishing.
Printed in Great Britain.

Contents

Introduction – When Is a Secret Not a Secret?

Keeping something quiet or concealed is exceedingly difficult in the modern world. A snippet of information on social media can go around the world virally in seconds, whilst advances in science mean we know more about the planet we live on than ever before.

There are so many books on the Dales which delve into its past – both archeologically and geographically – that there seems little else to discover. Indeed, I have already penned three books on the national park that uncover its gems and look at its socio-economic recipe.

Thing is, if you keep looking at something, or take a different stance, a new prespective always reveals itself. Historians are still discovering how people lived in this area every day; cavers are pushing the boundaries of their discoveries to reveal new entrances, longer tunnels and snapshots of geology whilst farmers are changing the way they work to adapt to the landscape and the issues we face through population increase and climate change.

That change, the circle of life and always wondering what lies around the corner – I'm a caver so forgive the pure optimism of my exploration – allowed me to uncover more secrets of an area I thought I knew pretty well.

> DID YOU KNOW?
> The last wolf in this country was killed on Wild Boar Fell.

I spoke to people who are managing the land differently, explored quarries that were once plundered now being overtaken by nature, and met entrepreneurs adapting to new opportunities presented by traditional methods. Then, there are pubs of yesteryear retaining their stories for future generations, modern-day mining enthusiasts protecting the past and notable folk still having an impact on the Dales whilst old thoroughfares, indelibly marked into the landscape they were designed to take people across, are still giving passage to wayfarers.

My journey brought me up close with fables and folk tales passed through families – in contrast with the 'new ways' – as well as new areas of the national park, opened up in 2016, just waiting to be discovered.

I'd like to thank Marcus Pennington at Amberley; Andrew Hinde at Natural England and his former colleague Colin Newlands; David Felton, Mark Richards and Colin Speakman at the Countrystride Podcast; Dr David Johnson for his tour of Thorns and

mind of information; likewise David Joy MBE; Lauren and Keith at Dent Brewery; Andrea Meanwell at Low Borrowdale Farm; Sam Moorhouse at Hesper Farm; Neil Heseltine and Leigh Weston at Hill Top Farm; Roger Pilkington for his picture of Hull Pot, and the cavers at ukcaving.com who helped me track him down!; everyone at Yorkshire Dales Millennium Trust but in particular Chris Lodge, Don Gamble and Judy Rogers; John Cordingley for his sheer knowledge of caving and cave diving ... as well as knowing pretty much everyone in the Dales; Jason Mallinson from the Cave Diving Group; caver Pete Monk for his Shuttleworth Pot pictures; Andrew Fagg, Luke Bassnett Barker and Lily Mulvey at Yorkshire Dales National Park, alongside their colleague and all-round legend Andy Kay who helped source many pictures for the book, most of them his own!; Sam Roberts and John Helm at the Grassington Mines Appreciation Group; Jack Overhill for not only his caving expertise and company on long caving trips but his sheer bloody-mindedness that led to many debates ... alongside his patience when the author was dangling from several ropes wondering what to do next; Steve Gray, Emma Key and my fellow cavers at Red Rose Caving and Pothole Club; Bill Nix for his stunning pictures of Lancaster Hole; Jonny Hartnell at Inglesport; and Nigel McFarlane for his guidance and editorial rigour. If I have missed anyone else, I am truly sorry.

I hope you find something within this book that will spark interest for further exploration and lead you to discover a secret no one else has found. If you do, you must let me in on it. Deal? Promise I won't tell.

Mike Appleton

DID YOU KNOW?
The stationmaster's house at Dent station, at 1,150 feet above sea level, was the first building in the British Isles to install double glazing. It was built in the 1870s and fitted with an extra pane of glass to protect it from the harsh elements. If you visit Dent station you can see the battered fences all around designed to keep snow off the tracks.

1. Landscape

The Dales has one of the most iconic landscapes in Britain. Its rolling hills and beautiful valleys are entwined with plunging waterfalls, magnificent caverns, and a carpet of limestone pavement. The recipe keeps tourists coming back for more, whilst providing a living for those that work with the land.

It is obvious that the landscape here has been transformed over millions of years, by the dramatic tectonic movement and seabed deposits that underpin that terrain today. The Dales sit on the Askrigg block – the area's geological foundation – and while you cannot see a lot of it on the surface, it governed how the carboniferous rock was laid on those seabeds.

That rock also had its faults ... positive ones – from the North, Middle and South Craven faults in the south to the Dent and Stockdale examples in the west and north. These moved and forced limestone and other rock in all different directions, creating dramatic landscapes such as Giggleswick Scar.

It is thought that three Ice Ages helped shape the Dales. Glaciers from Scandinavia, Scotland, the Lakes and Pennines merged to create the limestone scenery. It gouged out glacial troughs and blocked up the caves that had been forming over many years, until meltwater opened them up once more. That water, many millions of gallons, also formed valleys like Trow Gill near Clapham and the dramatic Gordale Scar near Malham.

Those sheets of ice exposed the Millstone Grit rock at the top of each of the Three Peaks. This formed when coarse sand mixed with quartz and crystals and was washed downstream from the granite mountains in the north by strong tropical storms. The limestone pavement, so famous throughout the park, appeared from the ice and was then subject to rainwater which seeped into fissures known as grykes. The powerful ice floe took limestone from the edge of stronger beds to create long lines of scars.

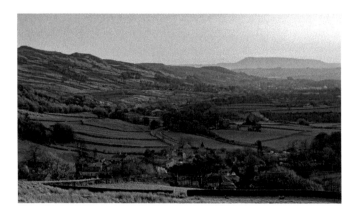

Looking towards Langcliffe, Settle and Pendle Hill from Bargh Wood near Stainforth.

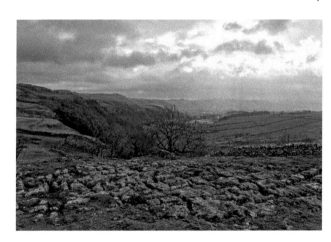

Giggleswick Scar is an impressive part of the landscape..

...and has plenty of interesting places to visit on its roof.

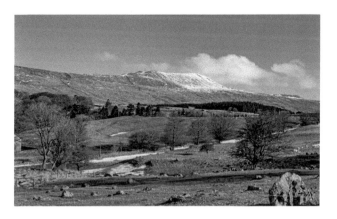

Whernside, one of the famous Three Peaks of Yorkshire, was shaped by glaciation.

Nature is a powerful thing and these processes – albeit less dramatic – still take place. Erosion will continue as the land is visited by wind and water, whilst human influence will always play a huge part in how this region looks.

The Dales is a worked landscape; a human landscape that is ever evolving. Farming plays a key role, with one in every six jobs in the national park being based in the sector. The lynchets of ancient field systems remain in certain places, and being engaged with the countryside is a way of life that is held dear to the hearts of those who exist here. The clipped fells that are synonymous with the Dales are as they were when they were drained and then grazed, and a hillside without perfectly kept walls and sheep would be alien to many visitors coming into the park – no doubt most locals too.

That landscape has come at an ecological cost. The Dales is second only to the Norfolk Broads in having the least tree cover in the country. Here, broadleaf woodland cover is at just 1.6 per cent, conifer cover at 2 per cent, whilst the country as a whole has lost 97 per cent of its wildflower hay meadows, mainly due to population increase and an agricultural system that has historically rewarded farms with bigger headage through subsidy.

Times are changing though, and several organisations, in partnership with farmers and landowners, are leading the way in reintroducing species-rich wildflower fields and new woodlands. The Yorkshire Dales National Park Authority (YDNPA) also met its target of adding a further 2,000 hectares of broadleaf woodland by 2020. 'Public money for public goods' schemes may trend this increase higher as subsidies are inevitably phased out.

According to the YDNPA in 2019, around 200 Dales farms – nearly one in five – had decided not to put land into the Countryside Stewardship scheme after their five-year Environmental Stewardship agreements expired. The main reason? The complicated process in applying for, reporting on and overall sustainability of the system, alongside the changes that will take place in public payments over the coming decade. Simply put, there isn't enough certainty to allow some farmers to proceed.

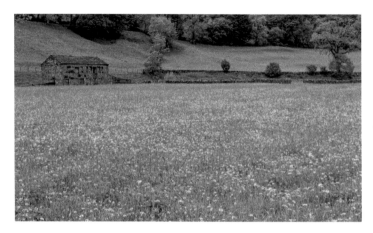

The Dales has lost 97 per cent of its hay meadows, but fine examples still exist in Muker (pictured) and other parts of the region.

That said, trials for the new Environmental Land Management scheme that will be introduced in 2028 have been encouraging, with a 43 per cent increase in plant variety in Wensleydale. It seems that payment by results, if explained clearly, could work in this part of the country.

Dales farmers are passionate about their landscape and want to keep it viable for future generations, but it is clear these schemes need to be attractive to not only support them to help the environment but to stay afloat.

One farm that has undergone a complete transition over the last twenty years is Hill Top Farm in Malham. In its heyday, it had a flock of around 800 sheep, but its owners have now opted to take a different path, resulting in a completely distinct way of life – and a farming operation that is recognised across the country. Neil Heseltine and his partner Leigh Weston farm approximately 1,200 acres in probably the most well-visited village in the Dales. Neil's grandparents moved to the farm in the 1950s and his parents bought it some thirty years later. It was in his mum's side of the family before that.

Neil said, 'I wasn't always thinking about agriculture and it wasn't always what I was going to do, but I never really had any thoughts of doing anything else. I went away to agricultural college and worked on a farm in Northumberland. I then played rugby for the best part of a decade. I played for Kelso and Wharfedale semi-professionally and worked on local farms, did some milking, and sold animal feed. I met Leigh and then returned to the farm full time after the 2001 Foot and Mouth outbreak.'

Hill Top has seen many changes since those early days and is now farmed in a sustainable way that complements the local environment. They use a grazing system that actively looks to put carbon back into the soil with reduced numbers of livestock. It can appear at odds with other farming practices but, as Neil explained, it is their story of how they produce their food.

'In 2003, as part of the Limestone Country Project, we introduced nineteen Belted Galloway heifers and a bull. The scheme's idea was that different grazing practices would help regenerate some of the habitats in the national park. Before then, subsidy pay was based on "headage" – the more sheep and cattle you had, the more subsidy you

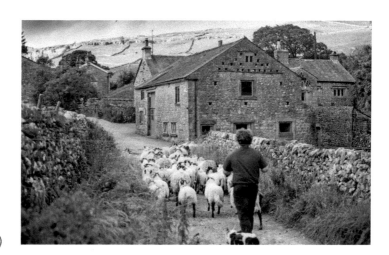

Neil Heseltine at Hill Top Farm. (Stephen Garnett/Hill Top Farm)

could claim. In my view that encouraged massive amounts of production and I believe overstocking on most farms. The results on the uplands, particularly in the Dales, was a higher concentration of sheep grazing, but some people would say that if you go back thousands of years there was a heavier population. This meant the flora and fauna, as well as the biodiversity, declined on those pastures.'

The Limestone Country Project sought to introduce native cattle into sensitive areas of the Park, and Hill Top Farm was part of that map. The programme set limits on stocking density and when cattle could be put on the land.

'It was a great project and really taught us a lot,' Neil continued. 'It made me begin to understand how the way we managed the land and how we grazed certain areas affected the biodiversity of those pastures. It sowed the seeds and as part of that we got into Higher Level Stewardship schemes and hay meadow management.

'After a while we started to reduce sheep numbers and increase cattle numbers. At our height we had around 800 sheep, but we are now down to around 150. We had no real concern in reducing sheep because we knew they weren't making us any money. It wasn't like we were going to lose anything by doing that. In fact, as a result of having less sheep and therefore lowering the cost structure of our sheep enterprise, they are now making a bit of a margin.

'What we have tried to create is a far greater balance between our production and the biodiversity on the farm, and mixed into that is how we live our lives. Having less stock and a different grazing system has allowed us to have a little more free time.'

Making the connection between farming, nature, and the food we eat is important to both Neil and Leigh, and they use social media to not only highlight what they do, but champion nature-friendly practices within the wider farming community. Check out @hilltopfarmgirl on Twitter and Instagram to see for yourself.

DID YOU KNOW?
Wildflower meadows grow better on unproductive soil. The key is not to allow grasses to dominate the flowers. There are a variety of ways to do this including introducing yellow rattle and other establishing wildflowers.

They are award-winning, and recently scooped a top accolade at the National Trust's annual Fine Farm Produce Awards, presented at BBC *Countryfile Live* at Blenheim Palace.

How does he feel about being a figurehead for nature-friendly farming?

'Am I a pioneer? I don't see that at all,' he said. 'I think what we did here was go back to traditional hill farming. What we are doing is probably more akin to what farmers were doing in the 60s and 70s. People say we are progressive in our farming, but I would say we are regressing ... going back to what it used to be.

'We've had some comments on how we farm, and I think we have been viewed as breaking ranks a little bit and perhaps being a little anti-farming. We have been in

conversations on social media with other farmers who have said that they expect to have to defend themselves from the public but not a fellow farmer.

'We want to differentiate what we do here. It doesn't mean that what other farmers are doing is necessarily bad, but we are going to question it. If you produce it that way, you tell people you do it that way and they are happy to pay for it and give you the price you're happy to accept then go for it. We use our platforms and our message to give people a choice in terms of quality and price.'

Neil and Leigh are clearly happy with the journey they have made, and the results are clear at Hill Top. Farmers are enormously proud folk though, especially in Yorkshire, and I wondered if Neil has any regrets about reducing his stock numbers all those years ago?

He's pragmatic about the decisions and their cost, but ultimately positive: 'When you make decisions, and a big one like we did on this farm, despite all the evidence, you do wonder if you've done right or wrong. At certain times of the year, I would have been stressed dipping and clipping gimmer lambs ready for market. As a farmer those events are something you aspire to. You want to produce much better lambs and the people who do that and do it to the "top end" are extremely skilful.

'I had clear goals when I came back to the farm here full time and I certainly didn't achieve them, so it is a failure in some respects. That said, it balances out with what we were making money wise and the impact it had on our lives. We've achieved things here that I never expected and both myself and Leigh are really proud of it.'

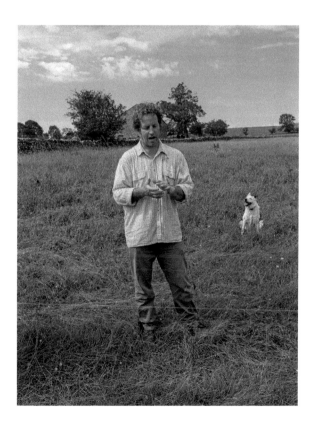

Neil doesn't see himself as a pioneer, but he is much sought after to talk about what happens on his farm. (Judy Rogers)

Neil and Leigh are very aware of the environment and how their operation affects it. It has brought some recognition nationally too and not just through awards. Neil is part of a number of nature-friendly farming groups, Chairman of the Yorkshire Dales National Park and very much a 'go to' when it comes to Radio 4's *Farming Today* programme. Agriculture, on the whole, has been placed firmly on the negative side of the climate change debate but Neil thinks the industry has as a real opportunity to make a positive difference: 'Two of the biggest issues facing the globe are climate change and biodiversity decline. I think we can turn that into revenue for farming if we grasp the nettle at this moment in time.

'It is a really important issue for us as a family and critically important to what is happening in the world today. People are looking at how meat is produced in the midst of climate change and it is something we take really seriously. We are taking those things into account when we are making decisions here. We believe it is critical that we live and farm in a different way to how we did over the last thirty or forty years.

'It is true that whilst some farms have increased the amount of food they are producing, it has had an impact on the environment and biodiversity. I also believe it has affected quality of life too. As that production of food has gone up, the profitability on farms has gone down. Subsidy has gone in to fill that gap and it distorts the picture. I think we have lost touch with those traditional farming methods; yes, agriculture is now bigger, brighter and better but it hasn't really progressed at all.'

Getting agriculture on board to help reverse biodiversity decline and its contribution to climate change is important – as is making the public understand where their food comes from and the quality of British production methods compared to those elsewhere in the world. Change is inevitable, but it will take a whole community effort as we progress into the future.

'I don't think that change is something we should fear – it is something that has happened in this landscape for centuries,' Neil added. 'I am excited about it as it creates an opportunity for farming to find a way of putting carbon back into the soil. Many landowners are reintroducing species-rich hay meadows and there are currently a lot of tree-planting schemes in the Dales. These will change the landscape. I suppose the way we

DID YOU KNOW?
The Dales has a smattering of ancient field systems which are still clear in the landscape. One example is between Clapham and Austwick on the southern border of the national park. Here, archaeology has revealed an enclosed settlement and field system that could be from Roman times as well as a cultivation terrace and lynchet from medieval times. It is thought the Romano-British settlement had three or four hut sites spread over half a hectare or more. This may be the original Austwick, which is less than a kilometre to the east. Another fine example of an ancient field pattern is at Howe Syke in Bishopdale, more than 6 kilometres south of Aysgarth.

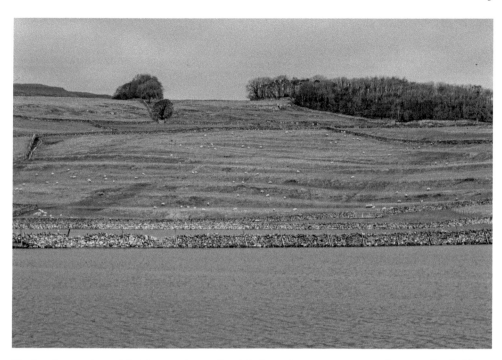

The lynchets at Austwick. There isn't usually a lake here, but storms Ciara and Dennis flooded large parts of the Dales in early 2020.

are heading at Hill Top Farm would be some people's version of rewilding. We are using stock to manage the land, increase biodiversity and moving away from mechanisation.

'The most important thing is we have to involve people in managing the land. I think the cultural heritage we have as farmers and our part in the community as farmers is important.'

2. Underground

The Dales has some of the most extensive cave systems in the world. They may not match up to the 640-plus-kilometre Mammoth Cave in south-central Kentucky, but the Three Counties System under Ease Gill near Kirkby Lonsdale, and the globally famous Gaping Gill, attract many visitors each year.

Above ground, the Yorkshire Dales offers much for the avid cave spotter. Swallow holes fall into the fell-side creating a sense of wonder, while show caves give a glimpse of just some of the caverns discovered in this special part of the country.

These systems are being extended all the time by a hardy set of explorers digging deep down in the earth to push for new discoveries. Ease Gill currently has around 90 kilometres of passages, but there' are 'pick-axe in hand' adventurers adding more every month. Cave divers go where normal cavers cannot: into murky sumps and water-filled passages to connect systems, and there are those that will move boulders in the search for new ways to follow – the real pointed end of speleological searching!

Ease Gill – a labyrinth of passages lies underneath.

Malham Cove

'In 1966 I stood looking upon at Malham Cove with my teacher Mr Preston telling me about the labyrinth of unexplored caverns which must lie beyond this impenetrable limestone impasse.'

John Cordingley is no ordinary explorer. Humble to the extreme, he has dedicated half a lifetime's work to discovering the massive cave system that must lie behind Malham Cove.

Set some 80 metres high, this limestone cliff is an instantly recognisable landmark in the Dales. Originally, a waterfall higher than Niagara would have flowed over it as a glacier retreated. Behind, meltwater carved out the Watlowes dry valley before it found alternative ways to filter through the fissures instead of plunging over the top of the cove.

Further up the valley, the water that flows out of Malham Tarn takes this old course and goes underground at Water Sinks – and it used to be the theory that this emerged at the bottom of Malham Cove. Dye testing has shown that this water actually appears south of Malham at Aire Head, whilst the cove's water is from a smelt mill some 3 kilometres away from the cove. The thought was that both rivers never mixed and thus there is one massive and complex cave system behind it. Or so theories go...

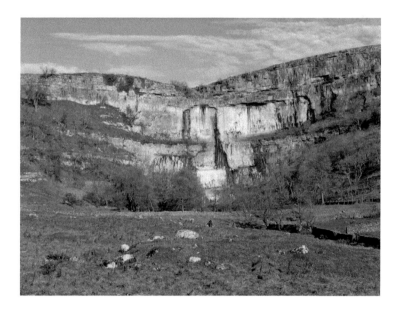

The impressive Malham Cove. (John Cordingley)

John and his team have dived the stream coming out of the bottom of the cove since 1988 and in more recent times, also explored a 'flood rising' nearby. His extensive knowledge of the system is second to none and he explained that the old hydrology of the catchment might not be what people think.

'The first serious efforts to discover the underground drainage at Malham was by the Yorkshire Geological & Polytechnic Society (YGPS) in the late nineteenth century,' he said. 'Their work included flood pulse testing, using the Malham Tarn sluice, and they established that in normal weather, sinks of the tarn water flowed to Aire Head Springs. They also showed that the smelt mill sink water drained to the cove. The "underground crossing streams" celebrated by geography textbooks ever since is based on this work.

'But, if you walk around the Malham area in very wet conditions, there's only one very big stream sinking – the Tarn outflow – and one big stream resurfacing from the base of Malham Cove. This simple observation suggests the YGPS' conclusions may be an oversimplification. Water-tracing over the years, with more sophisticated techniques, has shown that this simple model only really applies in dry conditions. Current thinking is somewhat more complex and exciting to geologists and cavers alike.

'As flows increase during very wet weather the tarn water overspills its low-flow sinks and travels progressively further down the valley, utilising older and older sinks. Eventually, it reaches the normally dry waterfall where the two dry valleys converge in the Watlowes and sinks in a large pool at the base of the fall. It was never known to go any further than that, in living memory, until December 2015, when Storms Desmond and Eva caused even this sink below the "dry" waterfall to overflow, allowing the stream to continue all the way to and over the cove.

'Most of the normally dry sinks in the Watlowes valley do drain to the cove and, as the flow gets further and further down the valley towards it, an increasing proportion of the water flows to the stream at the bottom of the cove. However, some of the water draining

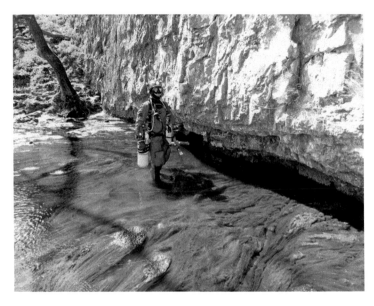

A diver at Main Rising.
(John Cordingley)

to the cove comes from further away to the north-west, from the Grizedale area and even as far away as Gorbeck. The old theory isn't really right; it's clear these underground flows cross and/or mix, depending on weather conditions.

'In times of extreme flood, a large amount of water also resurges in a field next to Malham village at a point called Cawden Burst. The stream sinking downstream from the Tarn has been tested to this flood rising, so it represents overflow from the yet unexplored passages upstream from the known underwater cave system at the foot of the cove. There's a big system here waiting to be discovered.'

Caves form on 'levels' as water sinks and finds different ways of percolating through limestone. At Malham, as John says, sinks above the cove are unlikely to flow straight to the bottom more than 80 metres away. The water will have formed an initial passage and then found its way deeper and so forth, repeating the process, until it emerged at the cove – and that's what John and his fellow divers are searching for. By diving upstream and working their way upwards using a variety of techniques, they hope to find a dry passage – and one that could eventually find its way to the surface. For mere mortals, it is dangerous work. Digging whilst diving in murky waters is hardly the idea of fun for most...

'I've been diving here since 1998 to find the big cave we know must exist here,' John continued. 'Although the part of the cave we dive in is filled to the roof with water, we know for certain that the rest of the cave mustn't be. We are trying to get through the underwater zone to get to the cave with airspace that must lie beyond. We have enlarged a long series of low passages by removing boulders and mud. Deteriorating visibility can be a problem, so we dive in winter as the water flow is stronger and it carries the mud away when you disturb it. For me, going to a football match doesn't give me the satisfaction being involved in a project like this.'

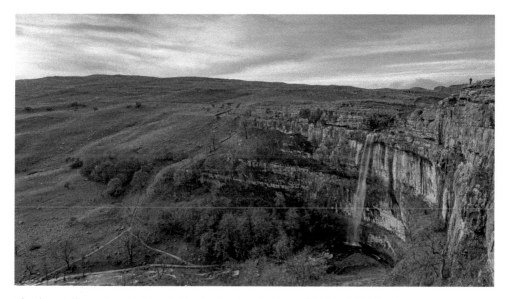

The day Malham Cove had a waterfall higher than Niagara. (Andrew Whitham)

DID YOU KNOW?
The thought of a massive cave system behind the cove is nothing new. Charles Tweedale had visions of the caverns in the 1930s and planned to start a dig to find out, but had no local support. He then plotted to do it under the cover of darkness but realised it was too big a job. He recorded his visions of the cave in a letter that he said should only be opened once the 'nature of the caverns' had been revealed by exploration. Unsurprisingly, whilst he was right about there being caverns, his visions were far removed from reality.

The attempt to discover this fascinating system began in earnest in 1953 as the Craven Pothole Club started digging near to where the water sinks. They reached a depth of around 26 metres before they were defeated by an increase in floor area which they just didn't have the resources to deal with. In 1976, the Northern Caving Club (NCC) dug out the flood rising and swam for more than 100 metres in the new passage. John arrived some thirteen years later and was involved in reopening the main rising at the bottom of the cove and connecting it with NCC's efforts.

He continued, 'Our work in the main resurgence revealed the Aire River Passage, which is 8 metres wide and 2 metres high, and eventually some 1.8 kilometres of cave. We discovered some beautiful cave passages but after thirty years of effort we gave it up. Eventually, at the main upstream limit, we encountered a collapse zone so extensive and so silty that we reached a point where we couldn't make further progress in this part of the system. After thirty years of continuous work, with dives sometimes lasting over five hours, we finally had to admit defeat. But all was not lost; there is another passage acting as a feeder to the underwater system, which we recently entered after moving sand and rocks aside.

'We named this Don's Way after Don Mellor who was the librarian of the Craven Pothole Club for many years. He was very interested in the possibilities of finding unknown caves at Malham. When we broke through into that passage, he had just passed away, so it felt more than apt to name it after him. The passage led us to another upwards boulder choke.

'We decided to make a determined effort here, because many flowstone pebbles have been found, leading to this choke. Flowstone is formed where water flows down cave walls or floors and only in air-filled passages, so perhaps we're finally barking up the right tree! The latest news is that the choke has now been passed and a larger section of passage has been entered, with a real atmosphere of age. This is still being explored at the moment.'

Whether John and his fellow divers complete the job depends on what lies around the corner. He has been diving for more than forty years and could be the person who rolls that last rock aside, his headlamp shining on formations never seen before.

'There is some degree of risk associated with this kind of cave exploration but with good techniques and long experience, such things are possible to carry out in relative safety,' he concluded. 'If we make a mess of fixing the guideline or miscalculate the amount of air

needed, then there will be no one else to blame. Yet, I feel safer then when on a routine journey in the car. The sense of control earned from planning and years of experience, in potentially dangerous and committing situations, is hugely rewarding.

'I know other people think cave divers are mad but why did Neil Armstrong put the first human foot on the Moon in 1969? It is exactly the same reason as why tens of thousands of people enjoy show cave visits every year. We're all curious; we want to go around that next corner and find out what's there.'

DID YOU KNOW?
The total catchment for two sinks that feed Malham Cove and the other risings cover 18 square kilometres.

Shuttleworth Pot

New discoveries can reveal more than just cave passage. On Leck Fell, and as part of the Three Counties System which lies underneath the Casterton, Leck and Ireby Fells, near the 627-metre-high Gragareth, a new pothole uncovered evidence of animal and human remains stretching back over millennia. As cavers progressed downwards from the surface, they found the bones of hyaenas, bears, hippos, reptiles, snails, and wolves alongside the remains of a man likely to have been alive between 2200 to 2026 BC.

Again, this cave was one opened by divers initially, before a real group effort broke out. Jason Mallinson and Rick Stanton connected Witches Cave, which is a flood resurgence for Leck Beck Head, with Pippikin Pot in 1997. Their upstream dive of around 500 metres – the full trip being 1.1 kilometres – had found a small shaft, leading to a large chamber. Their discoveries excited cavers from the Red Rose Caving and Pothole Club (RRCPC) but there was no dry connection for them to visit.

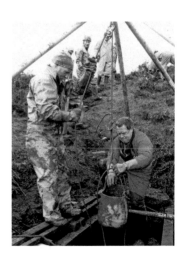

Grafting to open up Shuttleworth Pot. (Pete Monk)

Thirteen years later, and with the duo's survey in hand, a group of cavers managed to persuade Jason and Rick to make the trip again and place a radio beacon high in the chamber so it could be found from the moor above. They had a fair idea of where the cavern could be on the surface but needed to be sure. The underwater explorers agreed, made the dive, scaled more than 30 metres up the chamber into a passage and left the electrical device to enable the connections to be made. In May 2010, the signal was locked in and a small grassy shake hole – a 'pathetic-looking depression', according to caver Peter Monk – was identified as a likely digging spot.

DID YOU KNOW?
Just below the Lower Kirk Caves is Witches Cave, which is particularly impressive in flood as water flows at speed out of its entrance. It was first explored in 1849 by Henry H. Davis, who said it was 80 yards long before a pool was encountered ... but it is only around 25 metres before the passage is submerged under water.

Once permission had been sought from Natural England (the area was a Site of Special Scientific Interest) and the landowner Lord Shuttleworth, the honour of putting in the first spade went to Fred Rattray. He had designed the beacon and radio system, so it felt right to award him the duty. Progression was rapid with a team of volunteers reaching grooved rock within the first metre – showing the pot had taken water in the past.

It took fourteen digging trips to relocate the radio beacon and break through into the chamber discovered more than a decade earlier. The first descent was made by Dave Ramsey and Richard Bendall in October 2010, with later trips finding more remarkable items. Skeletons of palmate newt, although unconfirmed as they would have to be

Witches Cave.
(Pete Monk)

removed for analysis, are probably the first recorded example of this species from a true cave environment.

Then there were the remains of a dog found curled up in a corner. The thought was as it couldn't have survived a fall down the open shaft, then it must have come in via another route. Cavers have also revealed evidence of pigs, cattle, goats, deer, wild cattle (aurochs) and birds. When placing the radio beacon, Jason found a wild cattle tooth.

Dating this material is not an easy task as some of the bones here could have been washed in from the surface or could have been deposited by humans as part of rituals or simply disposal. Auroch, for example, have been extinct since the mid-Bronze Age!

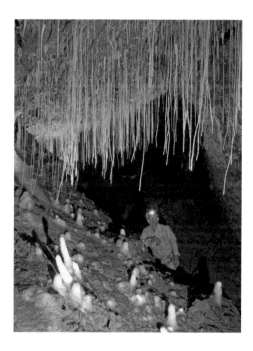

Some of the formations in Shuttleworth. (Pete Monk)

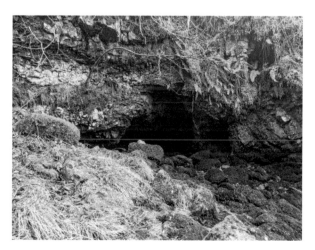

Leck Beck Head.

Lancaster Hole

Further up the gill is Bull Pot Farm, the home of the RRCPC. The club was formed in 1946 and its hut is a gateway to a caving cynosure. Taking the path from the farm, you pass Bull Pot of the Witches on your right, which has more than 2.5 kilometres of passage. Continuing on the path and turning left over the stile, after a few hundred metres is Cow Pot – the shaft's pink limestone walls descending some 23 metres to link up with other parts of the Ease Gill system.

There's no doubt the caves up at Ease Gill were known well before the current extensions. In 1936, exploration in Ease Gill found seven sinks. In the late nineteenth century, Bull Pot and Cow Pot were mentioned in writings and the former could be 'descended down to its downstream sump over 200 feet below without any tackle if care is taken'.

However, it was the discovery of Lancaster Hole in 1946 that proved to be the real turning point. Following a trip into Cow Pot, George Cornes and Bill Taylor noticed a small draught causing grass to move nearby. They pulled one rock aside and it tumbled down a pitch. They ran back to collect some rope, dropped it down the shaft and it went more than 34 metres below the surface. The discovery of several kilometres of passages

The entrance pitch to Lancaster Hole.

on various levels followed ... caving in this part of the Dales isn't easy as finding your way is a complex task.

The lidded entrance was the hub of the system, but further discoveries have created multi-entrances and various long trip possibilities. In the early days, the land was leased, and the lid was locked. That didn't stop other folk getting in, though, and as the system became busier some of its stunning features were damaged. The colonnade chamber for instance – massive columns from floor to ceiling – were vandalised, while crystal pools were damaged with mucky welly prints. Natural England, in conjunction with the Council of Northern Caving Clubs and RRCPC, now undertakes a lot of preventative measures and cleaning to stop any further damage.

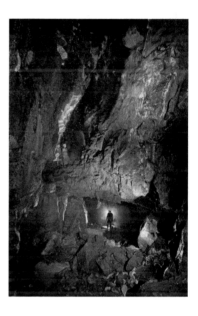

Bridge Hall in Lancaster Hole. (Bill Nix)

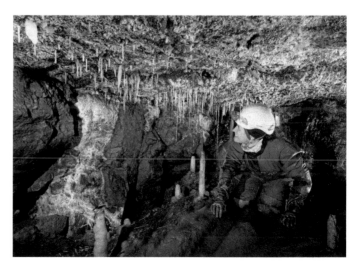

RRCPC club member
Emma Key at Slug World
in Lancaster Hole.
(Bill Nix)

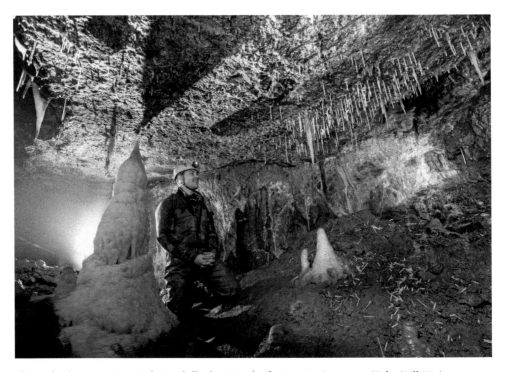

The author's cave trainer Jack Overhill admiring the features in Lancaster Hole. (Bill Nix)

Victoria Cave, near Settle

In 1837, Michael Horner was walking his dogs when one of them chased a fox into a hole. When it didn't return, he removed debris from around it and crawled inside only to come across several coins in the dirt. They were from the Romano-British period.

A year later, no doubt fuelled by the thoughts of further treasures, his boss began removing stones from the entrance, eventually discovering what was to become one of the most important caves in the world. He named it after the Queen who had just been coronated.

In the topsoil, alongside those coins, were other artefacts such as brooches. Pottery and decorated stones from the Iron Age followed and then a harpoon point, around 12,000 years old, was found – the first evidence of people in the Dales. Items from the Neolithic period were then uncovered alongside animal remains such as deer, horse, reindeer, and

the complete skulls of two grizzly bears. Discoveries continued with narrow-nosed rhino, hippo, hyena, and elephant bones – the hyena suggesting the site was used more than 130,000 years ago as their shelter and a place to hunt, when the climate was much warmer than it is today.

Understandably, Victoria Cave is a protected site and whilst you can go inside and explore, certain passages are blocked from public access.

Royal Observer Corps Monitoring Post

Moving away from natural caves to synthetic structures, the Yorkshire Dales housed eleven Royal Observer Corps (ROC) monitoring posts, with another five close to the boundary of the park, to measure fallout after a nuclear strike. They were built underground, usually close to aircraft monitoring posts, and were part of a network of 1,563 in the country.

Originally, nuclear monitoring stations would have been above ground, but it was quickly realised that these would offer minimum protection in an attack,

After a successful trial of the prototype post at Farnham, the Air Ministry Works Department and the ROC, with local contractors, constructed bunkers underground. In all but a few instances, they were built 11 to 16 kilometres apart from their neighbouring posts, so any monitoring data could be triangulated for a true picture of an attack.

Usually, they were of a standard design – at the bottom of a 4-metre access shaft, reinforced with 30 centimetres of concrete, sealed with bitumen and filled with limited provisions for up to fourteen days, alongside basic facilities such as a toilet and bunk, and important equipment to measure nuclear attack.

According to the website roc-heritage.co.uk, which documents the history and heritage of the ROC from its creation in 1925 through to final stand-down in 1995, 'air vents were covered by downward-sloping louvres above ground and sliding metal shutters below ground to control air flow during contamination by radioactive fallout.'

It is hard to imagine how the volunteers staffing these posts would have felt if HANDEL – the code name for the UK's national attack warning system in the Cold War – had warned an attack was imminent. Many had trained for such an incident, but in the run-up to war – a period of rising international tensions that many expected would proceed a nuclear war – how many would have left their families knowing they could be underground for up to fourteen days and the devastation a strike would cause?

Sitting on the ROC post at Dent, you get a small glimpse into the thoughts of those volunteers. You are enjoying such a beautiful landscape, and then the 'attack warning red' notice would be given. The ROC operative would sound the alarm, if in a rural area, and then get ready for the bomb to hit. Once it did, they would climb the shaft, open the lid and no doubt see the mushroom cloud rising.

From there, one piece of equipment, a Ground Zero Indicator, would be used to collect data from the 'flash' of a nuclear explosion. It had four 'horizontally mounted cardinal compass point pinhole cameras within a metal drum'. Roc-heritage.co.uk says, 'Each "camera" contained a sheet of photosensitive paper onto which was pre-exposed horizontal and vertical calibration lines and horizon level. The flash from a nuclear explosion would produce a mark on one or two of the papers within the drum. The position of the mark enabled the bearing and height of the burst to be estimated.'

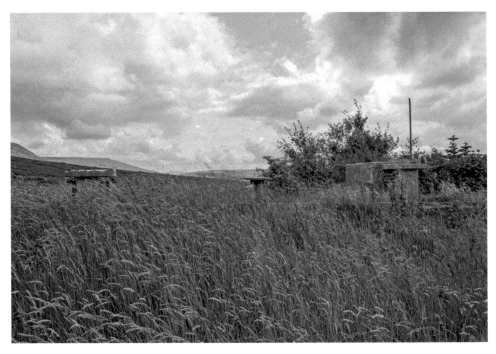

The ROC Post at Dent. A fantastic view awaited the volunteers, unless they'd been given an 'attack warning red'.

This information was important because an explosion near or on the ground would produce fallout, while an air burst attack would result in a much lower amount. It was also possible to measure the power of the bomb with a Bomb Power Indicator, using the pressure of an explosion through a baffle plate to measure its size.

The posts were built from 1955 but nearly half were closed in 1968 as the ROC changed its organisational structure. Of those that remained, several were subsequently damaged by flood and vandalised while the rest stood down in 1991, such as the one at Dent.

Many posts are still evident in the landscape but are often irreparably damaged and on private land. They should not be entered, and most are locked for obvious reasons.

DID YOU KNOW?
Bunkers in, or on the boundary of the national park, were at Aysgarth (opened 1965 and closed in 1991), Buckden (1963–91), Dent (1965–91), Grassington (1962–91), Hawes (1963– 91), Horton-in-Ribblesdale (1965–91), Kirkby Lonsdale (a master radio post 1962–91), Kirkby Stephen (1962–91), Reeth (1965–91), Sedbergh (1965–68), and Settle (1965–91). There were also sites at Bewerley, High Bentham, Gargrave, Leyburn, and Tebay just outside the border of the park.

3. Mining

Exploiting underground minerals was once a significant part of the economy of the Dales. Large-scale quarries still exist in Horton and outside Grassington, but the signs of the national park's industrial past are never too far from the eye.

Research by historians at the YDNPA suggested that chert – a type of quartz – was the first stone to be used in the Dales. 'Excavations at Malham Tarn show that the Mesolithic hunter-gatherers who exploited its rich wildlife, used locally gathered chert as well as flint carried in from the Yorkshire Wolds,' says outofoblivion.org.uk, a website based on the Historic Environment Record (HER) maintained by the YDNPA.

The first reference to lead mining in Grassington was in 1494 but Roman ingots made from lead suggest the substance was being used much earlier. By the eighteenth and nineteenth centuries, Swaledale and Wharfedale were mining hubs – Gunnerside, Grinton and Grassington all a hive of activity. Then there were coal mines, where peat and limestone were heavily extracted, the latter being used to neutralise acid soils.

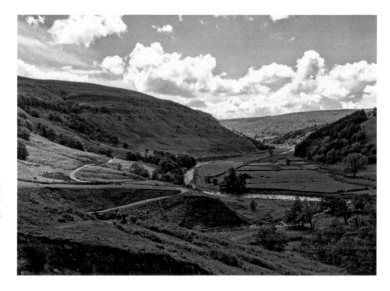

The Dales has always been exploited for its mineral wealth. Even in Muker, in such a dynamic landscape, there are signs of mining.

DID YOU KNOW?
A vein that comprised around 10 per cent or more lead ore was considered to be a rich mine.

Ribblehead Quarry

One of the best examples of an ex-industrial site that is being reclaimed by nature is at Ribblehead. Just behind the railway station, metres from the famous Settle to Carlisle line, is a nature reserve containing nearly 200 species of wildflowers, grasses, sedges, rushes and ferns including black knapweed, wood sage, northern spike rush, marsh helleborine, common twayblade and birds-eye primrose. Its transformation into a haven for flora and fauna is a far cry from the extensive workings that were present in the area in the last century.

Quarrying had taken place around the railway for more than 100 years with the Craven area having at least fifteen medium- to large-scale workings. At Ribblehead, the Craven Lime Company took out the lease on the land in 1895 and supplied crushed stone for rail ballast. They quarried on a small scale until 1943 when Leeds-based Horace Austin and Sons took control and installed crushing and screening plant to enable limestone to be processed for use in agriculture. They also applied to extend the site's area and deepen it to 15 metres to boost output.

In 1954, it was sublet to Messrs Adam Lythgoe of Warrington, and they gained consent two years later to extend the quarry to 10 hectares and add to its facilities. After a downturn in the industry in the early 1960s, it was put on the market and some of the older plant was demolished. Amey Roadstone Corp, which eventually became Hanson Aggregates, took over in 1973, and they wanted to install new equipment and a rail link. The plan was to reopen the quarry in 1979 after the work had been completed and then supply stone to the coal mine at Selby. That contract never came to fruition and even though there were 23 million tonnes of reserves – significant enough to secure the company's future – constraints around planning made any further extraction exceedingly difficult. Faced with these insurmountable problems, they gave up quarrying rights in 1998 and two years later handed the site over to English Nature – now Natural England.

Until recently, Colin Newlands was the manager of Ingleborough National Nature Reserve, which held Ribblehead Quarry within its bounds. He said the restoration plan for the site was to mimic a post-glacial landscape after the last Ice Age by creating shallow pools, mounds, scree slopes and open ground on the quarry floor. These features supplied an opportunity for plants and animals to colonise the former quarry.

'Ribblehead Quarry came into the Reserve on 13 October 2000 after it was gifted by Hanson Aggregates,' he explained. 'The idea was that it would be left to develop as naturally as possible, and it would also be a place where people could come, appreciate wildlife and see it close hand.

'There was a restoration plan drawn up and the emphasis was on taking a "light-touch" approach. They didn't want to plant lots of trees, spread topsoil over the site and try and re-establish vegetation by sowing imported seeds. There was some light planting of native trees and shrubs within the quarry, including juniper and downy birch, but they wanted to allow the quarry floor and the spoil heaps to colonise naturally.

'The reason was to allow a natural succession process to take place and not have a plan that determined how the quarry should look in five years' time, or the species within it. They were keen to see how nature recolonised this post-industrial site in the heart of the Three Peaks area.

'It was fortunate that there were species-rich habitats close to the site, which meant the quarry could receive a good seed rain from its surroundings. The ability of plants to come in without being brought in deliberately was significant. The site is still very much managed to allow that to happen. Grass cutting is carried out on some parts of the quarry at the end of summer to increase the wildflower cover but other than that, and occasional ragwort and thistle control, we don't do a great deal of management.'

The proof of this approach is pretty staggering. In what could have been a quarry to rival, in size, the one nearby at Horton, you have hundreds of diverse species, some of which are nationally rare and others scarce. Regular analysis of the amphibian population as part of the National Amphibian and Reptile Recording Scheme shows impressive numbers of frogs, toads, and palmate newts, and it is a beautiful place for breeding birds too.

It is used by local schools and colleges for study and research; there's a well-used geocache trail and you can download an archaeology app which will guide you around the site and take you to the Viking-style house and settlement at Gauber. Near the entrance is an audio post with eight short recordings about the history, wildlife and geology of the quarry and surrounding area.

'The site has a rich industrial and archaeological heritage and is also a good place to visit for recreation and to appreciate the landscape,' Colin continued. 'From it you can see the Three Peaks and the magnificent views over the viaduct; you can look across the valley and see where the cattle drovers met and trace the Roman marching road from Bainbridge. It is also a place you can learn about the geological processes that made the Dales landscape.'

'There is a "geology seat" for visitors to rest at and admire the quarry and its surroundings. Its profile reflects Ingleborough, Park Fell and Simon Fell. It was built to help explain the local geology and you can see the various rocks that make up the landscape in their correct sequence. It also has a miniature working cave system, and

Nature is reclaiming Ribblehead Quarry after years of industrial activity.

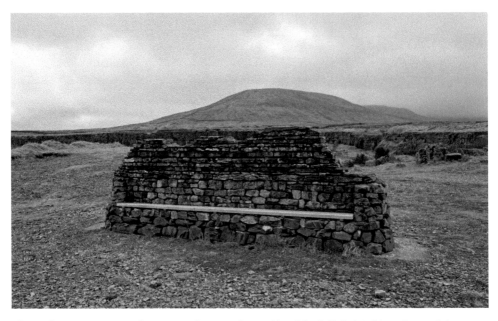

The multi-purpose seat at the quarry, showing the profile of the hills behind it and containing a cave system inside!

a little water poured in at the surface will re-emerge where the limestone meets the impervious bedrock.'

He concluded, 'It will be fascinating to see what happens to the quarry in the future. This landscape, in the absence of human beings, does want to go towards woodland – that is what it originally was before it was cleared and farmed. The quarry is a long way from that of course; it has been colonised by pioneer plants, but that will change as this process of succession continues naturally to scrub and then to woodland.'

'In the future I have no doubt that the reserve will want to keep some areas open within the quarry in order to maintain a variety of habitats and maintain the diversity of plants and animals that they support. It will always be a quarry, that will always be clear, but it will be exciting to see what happens.'

Gunnerside

Gunnerside Gill was the hub of a lead mining industry that once covered much of this picturesque dale. The valley still holds much of its industrial past with dammed streams and old workings easily visited, alongside the hushes which cover both sides of the gill. These were created when water from dammed streams was released at great speed to remove soil from the surface, exposing the lead ore seams. The ore could then be recovered and crushed for smelting.

In Gunnerside village is the Old Working Smithy & Museum and it is well worth a visit if you want an introduction to that history. The smithy itself was established in 1795 and has several superb artefacts on display.

The remains of Bunton Mine with the Gunnerside Gill landscape. (Bernd Brueggemann / Shutterstock.com)

DID YOU KNOW?
Black marble limestone, seen around Dentdale, doesn't look remarkable but when it is polished the white fossils inside create striking patterns. It was popular in the nineteenth century for mantelpieces, fireplaces, and marble columns.

Kilns

These old structures hark back to a past when limestone was heated and then spread over the landscape to reduce soil acidity, and used in other applications such as tanning, textiles and paper. There are fantastic examples on the track from the Old Hill Inn in Chapel-le-Dale to Ingleborough – the Philpin Kiln – and further down the road at Ribblehead.

Probably the most well-preserved 'industrial' kiln is the seldom-visited Hoffman Kiln near Langcliffe. Built between 1873 and 1876 for the Craven Lime Company, it had twenty-two separate burning chambers and was lined with firebricks, insulated by limestone rubble, to maintain heat. The kiln would be stacked, by hand, with limestone and coal, a process which would take around five days. Once lit, crushed coal would be dropped into the chamber from above through small chutes – all still visible today.

Flues in the walls allowed air to circulate and they were controlled from the roof. It meant that heat could be regulated and as one chamber burned, its neighbour would begin to heat up too – a very clever way of supporting energy efficiency in the system. Not all the chambers would be in use as when some were cooling, the lime could be manually collected and put on railways outside. It was dangerous, horrible work in raging temperatures.

Outside, the evidence of the sidings, tunnels and other workings can be visited and just to the top left, you can walk down to a rival company's kiln – that of Murgatroyd – built close by.

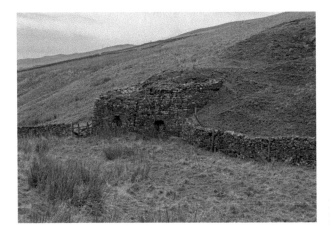

Kilns are a significant part of the Dales landscape.

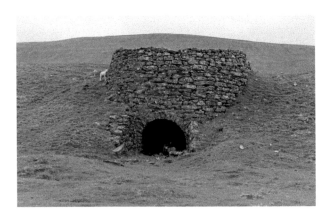

The Philpin Kiln on the path up to Ingleborough from Chapel-le-Dale.

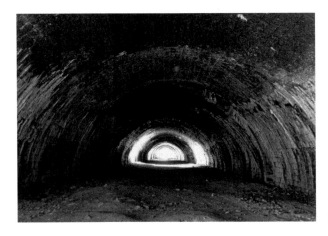

Inside the magnificent Hoffman Kiln...

The Hoffman Kiln was in use until 1931, although it was briefly reopened six years later before finally being closed in 1939. It was also used as a chemical store in the Second World War and later by Craven District Council as a landfill site.

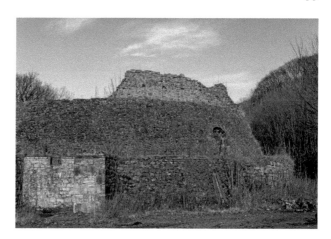

...and outside.

Smelt Mills

There are some fascinating mills in the Dales which have been suitably preserved to maintain the link to the industrial heritage of the national park.

At Grinton, there is the smelt mill and flue, fuel store and remains of a further building alongside dams, leats, trackways and inclines. It was built before 1733, renovated less than ninety years later and then refurbished in 1890 when a scotch hearth, slag hearth and roasting furnace were added. It is a Scheduled Monument that the national park has worked hard to protect. In July 2019, floods swept away an historic, listed stone arch culvert which covered a watercourse running next to the mill, and it was clear another flood would jeopardise the mill building itself. The National Park repaired the eroding watercourse edge and installed 'rock armour' in vulnerable areas, using local contractor Peter Iveson of Hawes. The work took place in February 2020, just a few days before Storm Ciara brought widespread flooding to the area.

The Old Gang smelt mill near Reeth was built in the late eighteenth and early nineteenth centuries and was later used for the reprocessing of barites. This barium sulphate wasn't

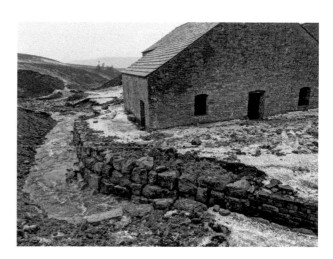

Grinton Smelt Mill in Swaledale was protected from Storm Ciara in the nick of time... (Andrew Fletcher / Shutterstock.com)

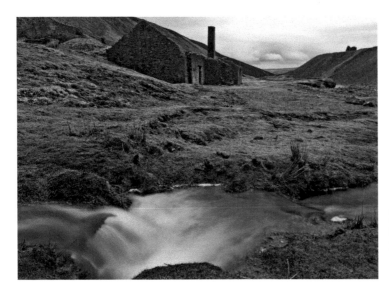

Ruins of the Old Gang Smelt Mill near Reeth. (Phil Silverman / Shutterstock.com)

smelted but used as it was, crushed as a filling agent in paper, rubber and also as a weighting agent for oil field 'mud' systems.

Langrothdale hosts a multi-period settlement and mining complex on the west side of Deepdale Gill. As well as having evidence of a hut circle from the Iron Age or Roman times, it also shows signs of lead mining and associated workings during the medieval to early post-medieval periods.

Buckden Old smelt mill is another site worth seeking out. It was built in 1698 and worked until the early 1730s. The lead ore came from the Buckden vein being mined further north.

DID YOU KNOW?

Miners were considered the lowest orders of society, especially by the established Church. More consideration was focused on the risk taken by mine owners, who were normally very well-off. In *Men of Lead*, David Joy referred to the Revd Doctor Thomas Dunham Whitaker as having particularly strong views on those that worked underground.

Whitaker wrote in *The History and Antiquities of the Deanery of Craven* that miners were 'the mere trash of the churchyard'. He also believed in a 'divine class structure' and would later write (in *History of Richmondshire*) 'I do not know of a greater calamity which can befall a village than the discovery of a lead mine in the neighbourhood.'

Joy also points out that Whitaker called miners 'colluvies' – an unpleasant term for 'collections of filth or foul matter who contributed more to an increase in population than to the improvement of order and good morals'.

Grassington

The moor above Grassington was one of the most extensive lead ore mining sites in the country. The land was worked from the early seventeenth century, but there is evidence of mining from 1494 and lead was certainly used in the Roman ingots discovered in the area. Early mines were bell pits, with a small driven shallow shaft which allowed the miners to work laterally at the bottom.

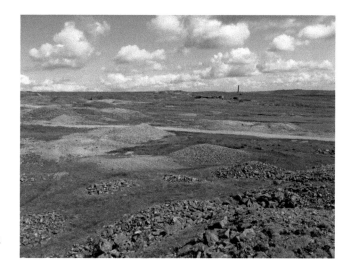

There are an estimated thirty to forty shafts on Grassington Moor. (David Joy)

Transition to Devonshire

George Clifford, the 3rd Earl of Cumberland, inherited 90,000 acres of land of which Grassington Moor was a significant part. He sold that land in 1604 but kept the mineral rights, bringing in skilled miners as well as building a smelt mill close to the river at Linton. He died in 1643 when parliamentary forces besieged Skipton Castle during the English Civil War. His mineral rights passed to daughter Elizabeth and she married Richard Boyle, 2nd Earl of Cooke and Earl of Burlington. He didn't have an heir, so when he died in 1643, his daughter Charlotte took control of his estate. She married William Cavendish, who was the son of the 3rd Duke of Devonshire. The mineral rights still rest with the family today.

The Devonshires, over subsequent generations, transformed the viability of Grassington Moor until the last working mine closed in the late nineteenth century. Those first shallow shafts gave way to extensive workings after 1756, before pumps were installed to get at the rich ore that could be found beyond 90 metres. However, within twenty years those new levels hit the water table and progress slowed. Seeing his returns starting to diminish, the Duke agreed to build a deep adit called the 'Duke's level' to drain Yarnbury and Out Moor Mines, which would double the depth at which they were workable. The idea was to drive a channel wide enough for a canal that could be used to bring out the ore. It was a huge undertaking, but ultimately proved unworkable due to the sheer size of the cutting needed to take a wide enough tunnel the full 2.5 kilometres from Hebden Bridge.

Linton in Grassington. George Clifford built a Smelt Mill here.

DID YOU KNOW?
As mining fortunes fluctuated, so did the population of Grassington. In 1803, it had just seventy-five miners and twelve farms, with the population rising to 1,067 just over twenty years later.

The Duke's mineral agent John Taylor took charge in 1818 and one of his first tasks was to halt the work of the Duke's level. He'd realised that costs were out of control and progress was too slow. He ensured it would still be completed but not to the scale of an underground canal. Taylor also leased out the mines, which meant that the Duke's operation incurred no costs, but the estate could pick up duty payments in the process. He also invested some of that money back at Yanbury and Coalgrovebeck to increase productivity – so the Duke could enjoy the benefits.

That change in management saw more than 1,000 tonnes of ore mined by 1825, and the population of Grassington rising to 1,067. Yet, by 1830, problems at Coalgrovebeck and a bad winter led to many miners leaving – some heading abroad – but the Duke's level opened at the same time to allow better drainage and deeper working.

These changes alone should have ensured a viable operation for the Duke, but it was the increasing lead price that brought a real renaissance. Cornish mining expert Stephen Eddy replaced Taylor, and he revolutionised the workings to take advantage. He installed flues, condensers, and the tall chimney you can still see on the moor.

Mining peaked in the first half of 1850s but just a decade later, imports rose, and the veins were producing less lead. By 1882, the final mine closed, although there was some working of spoil heaps in the 1940s to 1960s for gangue materials such as barites and fluorspar. By the end of the nineteenth century, Grassington was shadow of its former

self, but the arrival of the railway in the early 1900s at least brought a boom in tourists to bolster economic activity.

Grassington Mines Appreciation Group

Established in 2017, the Grassington Mines Appreciation Group is a small group of individuals interested in the exploration, documentation, and preservation of these important links with the past. The committee of Sam Roberts, John Helm and Adam Clenton are passionate about the mines on the moor and have set out to not only explore what is there but also document it for future generations.

'Before I met John, I was looking on Google and noticed that the mines on the moor weren't very well documented,' Sam said. 'There was a small amount of exploration done by various groups, but it wasn't to any great detail or depth. There was also a little bit of exploration undertaken by the Bradford Pothole Club, of which I am a member, as they looked at the old manway shaft in the turf pits. It was believed there were lost caverns to be found but they didn't have any luck.

'Curious, and as a caver myself, I asked around to see if anyone knew about the mines. Firstly, the members of the Upper Wharfedale Fell Rescue Association (UWFRA) didn't have a lot of knowledge, and secondly few people seemed to have explored the mines since they closed. That was an important thing for me; I knew there could have been anything down there and knowing no one had explored them since they closed gave me a real excitement of exploration.

'The group started off with me and John documenting what was up on the moor, and it came to a stage when we wanted to know what people thought of our explorations. We wanted to share our knowledge. We made a small private group on Facebook to share videos and images and we found a really big interest in what we were doing. It has grown from there and now we have more than sixty-five members and close to 300 on Facebook.'

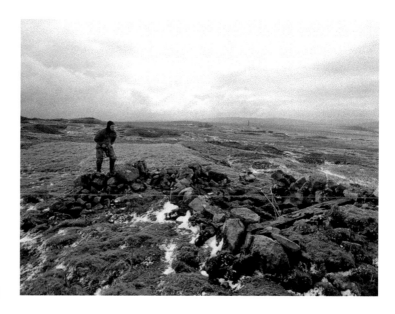

One of the Grassington Mines Appreciation Group **members** getting ready to explore one of the mines. (Grassington Mines Appreciation Group)

Sam says that exploring these mines requires a high competency in single rope technique – an advanced system of caving – and a high degree of caution. These aren't mines you can go in and have a look around – even for the most natural cavers – but there is a Grassington lead mining trail that will give you a basic understanding of what is under your feet.

'We cannot be clearer: these mines aren't safe to explore,' he continued. 'You shouldn't wander freely across the moor as there are shafts you may be standing on that aren't obvious. Some are covered in wooden sleepers that are rotting and are very deep.'

John added, 'That was one of our drivers for setting up the organisation. The shafts are in a poor state of repair and many of those wooden sleepers now have a thin covering of grass so you would never know what you are standing on. If you do, then there is a fair chance you could break through and fall up to 80 metres. Sam and I are both members of UWFRA and if a fall happened then one of us would be called to pull you out. That isn't acceptable to us, to know there is a risk like that up there. By documenting what is there, if an accident does happen, then we have knowledge of what to expect.'

John has been caving for forty years, used to be an instructor at the former National Caving Centre near Dent and is a geologist by trade.

He continued, 'We want to see these mines conserved as they are an important part of the history of Grassington, where I was born. They need to be made safe, but we know it is difficult to build walls or fences around the shafts as the workings and spoil heaps are a Scheduled Monument. We are in the process of working with stakeholders to see the best way of progressing as ideally, we would like to put simple fences around the shafts.

'We know that the Duke of Devonshire doesn't own the moor but has the mineral rights. The shooting rights have been sold off and the land is common land. Research can't trace who actually owns the land, so it is run by the Grassington Moor Management Association. Our group isn't in anyone's camp; our only interest is making the mines safe.'

Sam added, 'In modern-day health and safety, whoever owns the land has a responsibility for its safety, but it isn't as clear as that at Grassington. For example, if a mine is worked prior to 1872, according to the Mines and Quarries Act, then the owner

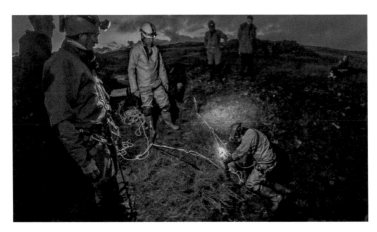

Time to explore ... everything is meticulously checked before a descent is made. (Sara Spillet)

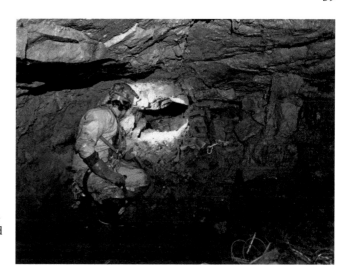

Underground ... the group has found all sorts of artefacts and passages. (Grassington Mines Appreciation Group)

doesn't have a duty to protect the shaft. Chatsworth Estate has the mineral rights but isn't bound under the legislation. It's a complicated situation.

'We think some of the shafts were covered in the 1960s, but that isn't certain. What is certain is that we can get things done. We have been offered funding to put decent fencing around some of the shafts but because the mines are Scheduled Monuments, they shouldn't be disturbed without Scheduled Monument Consent, and that includes some of the surface features. We know we will get there in time as the National Park Authority and Historic England are keen to see it happen.'

As there are probably thirty to forty shafts on the moor, the work that Sam, John, and Adam could have on their hands is clearly extensive. It also has a dual purpose – expanding the knowledge of what drove Grassington's development in the eighteenth and nineteenth centuries.

'We want improve people's knowledge of the mines,' Sam continued. 'All you have at present is the lead mining trail which gives a brief history. We've found some incredible things on our explorations and know there is more to come. We've found footprints that would have been from the last people who were down the shafts some 150 years ago. Then, there are carvings on the walls, rock drills that make shot holes, and where the miners have gouged out clay to put their candles in.'

To find out more about the Grassington Mines Appreciation Group, visit www.grassingtonmines.com.

DID YOU KNOW?
Women never went underground but they worked on the dressing floors. They would dress the lead with water, while water was the last thing their mining husbands wanted to see!

4. Cottage Industries

Like many rural areas, affordable housing is key if you want to keep young people in the Dales. Currently, the number of people living in the park is static, but trends show it could decline 9 per cent by 2040 if youngsters cannot get on the property ladder.

According to the national park, halting that decline would probably require the building of at least fifty dwellings a year, with twenty of those being affordable, but people on rates of pay equivalent to that of nurses, firefighters and teachers currently need more than five times their annual income to buy even the cheapest housing in the region.

Encouragingly, organisations are working towards meeting this demand, as are those who are looking to make sure talent is not lost from the area. Yorkshire Dales Millennium Trust offers countryside apprenticeships for younger people, and their success rate of around 85 per cent in getting those to progress to further training or employment is higher than most across the country. There are others too, and overall employment has grown significantly across the park in recent years, especially in the accommodation and food services sector.

DID YOU KNOW?
Official figures show that since 2010, there has been a continued marked increase in the number of over-65s living in the national park, with a corresponding marked decrease in the number of children living there. The resident population of the park has fallen by just over 500 people over the same period, and now stands at 23,488.

This little secret is the Home Farm Dairy Barn – a mobile vending machine that sells fresh free-range milk from the Home Farm, a small family farm, in Aysgarth. It also sells a Wensleydale cheese called Old Roan, made in small batches by hand. It is a traditional recipe and uses raw milk. It's phenomenal! Find out where it will be on your visit to the Dales at www. thehomefarmer.com

The park is successful at garnering 'cottage industries' with a number of entrepreneurs carving out their own niche, and more importantly, providing that employment to keep people in the Dales. Small-scale manufacturers, microbreweries and dairies boost the economy alongside the more traditional farming and tourism sectors.

Wensleydale

Cheesemaking in the Dales occurred long before the celebrated Wensleydale dominated production. Small farms would have made their own version based on recipes passed down through the generations, and it is thought that the first types were of a blue variety, crafted with sheep's milk.

Wensleydale cheese itself was first made in the twelfth century by French Cistercian monks who had settled in the area. It remained largely within the confines of the monasteries until the Dissolution, before recipes were passed to farmers' wives. More than 350 years later in 1897, the first creamery was built in Hawes and local merchant Edward Chapman began to produce it on a larger scale. Economic depression in the 1930s almost forced that dairy to close, but Kit Calvert, mobilising local support, helped it to survive. He kept it going before it was sold to the Milk Marketing Board in 1966 only for Dairy Crest to close it twenty-six years later and transfer production to Lancashire. That did not last long though as six months later a team of four ex-managers and local businessmen made a deal to buy it back.

Today, the creamery is a local employer which uses local milk from local farms to make its famous products. It has won more than 400 awards for its products, which also include Double Gloucester and Cheddar as well as sheep's cheese.

DID YOU KNOW?
Many dairies make Wensleydale, but Yorkshire Wensleydale has Protected Geographical Indication (PGI) status. That ensures no other cheesemaker outside the area can make cheese and name it Yorkshire Wensleydale.

Knitting

From the fifteenth to the eighteenth centuries Yeomen and their families scraped a living in Dentdale, by being self-sufficient on small areas of land and grazing their animals on the commons. They owned a narrow strip of bottom land and a narrow strip of fell, evenly distributed amongst the villagers. They also supplemented their income by knitting and whole families were involved in the production of knitted garments like stockings. For the Seven Years' War, between 1756 and 1763, the government placed agents nearby to secure the 'worsted stockings' for the English army. The garments produced by the Dales-folk were of excellent quality due to the Dentdale wool – and they could be made quickly. In 1801, it was recorded that an average of 840 pairs of knitted stockings came from Sedbergh and Dent. Gloves and hats would also be made and sent by pack pony to Kendal and beyond.

The 'terrible knitters', as they were known, worked in clusters and had a reputation for being great gossips. 'Terrible' refers to the ferocity in which they knitted but also the way protagonists of the craft would rock backwards and forwards whilst removing the loops. The extra money – 'knitting brass' as Colin Speakman, Adam Sedgwick's biographer, called it – went a long way to keep the population just above the poverty line.

But after the common land was enclosed in the nineteenth century to increase the efficiency of agriculture to feed a growing population, it was these yeoman farmers who lost out. They lost the right to graze on their common pastures and then came machination and the large-scale factories in Kendal and West Riding to end knitting as a cottage industry. Dent, which was once bigger than Sedbergh, saw its population decrease from 1,773 in 1801 to just 590 in 1971. The farms that remained eventually became bigger through amalgamation, and when mill and factory owners came to the area looking for a rural retreat, they bought the land. Trade and service industries disappeared too as there was no influx of people.

The remnants of knitting still hold strong in the traditions of the community though, and you can see the 'picks' used in this industry in the fantastic Dent Village Museum and Heritage Centre which is on the left as you leave Dent towards Sedbergh.

Skyr Yoghurt

The Moorhouse family have farmed at Hesper Farm in Bell Busk for three generations. The dairy farm is renowned for its pedigree herds, with its Aireburn cows nationally recognised for their quality. They've been a lifetime's work for Brian, who has moulded the operation into one with the utmost welfare standards for its cattle, and a real care for the environment. Like all dairy operations, they are at the whim of the milk price and so have taken on diversification as a way of sustaining the business.

But did they open a B&B, farm shop or other enterprise? No, they opted to become the first farm in the country to make a particular type of yoghurt: skyr. It was the brainchild of Sam, Brian and Judith's son, and quite simply his passion and desire to succeed.

'From an early age I realised how difficult being a dairy farmer was,' he said. 'Dairy and farming in general has always been challenging and a big commitment. We didn't struggle as such when I was young, but I realised you had to put in a lot to get something

Hesper Farm, the home of Hesper Skyr, its Aireburn herd...

out of farming. Perhaps from these early days I formed the mindset that when I took over the farm, then maybe I would have to do something different or certainly look at doing something different to make it more stable and less pressurised.

'That's not to say I didn't enjoy it. From a young age I got stuck in and enjoyed being around the farm and exploring the local area, but I did see how under pressure my mum and dad were.'

After growing up at Hesper, Sam went to Reaseheath College in Cheshire, completing a National Diploma in agriculture, before travelling to Norfolk to sample arable farming and then to Australia. On his return, at the age of twenty, he pitched in where he could but had already begun to work on ideas that could make a difference.

'That's when I first read about Icelandic cows!' he continued. 'One of the primary products of the dairy industry in Iceland is skyr, a high-protein, high-calcium and low-fat yoghurt. It struck a chord with me as people were looking for high protein in their diets and further research revealed that it wasn't a widely known product. In the end, I decided to travel to Reykjavik to find out more.

'I asked around local delis about how skyr was made and was introduced to Thorarinn Sveinsson. His family have been dairy technicians for many generations, and he managed one of the big skyr factories in the country before he semi-retired. He agreed to pass over his knowledge and show me how to make skyr.'

Back in the UK, Sam knew that skyr could be a high-quality product and sold through local farm shops. Excited, he researched trends, put a business plan together and then presented it to the bank.

'They rejected it,' he continued, 'which was fine as it was terrible, but their response did allow me to pause and rethink. I didn't have any real business skills; I was a farmer, and the plan needed a marketing strategy and research to back it up. I did a lot more work on the second plan and it was successful. I know the bank were pretty reluctant to lend me the money but the one thing I did have was the farm, and therefore I could secure it in one way or another.

'I suppose I "bet the farm" on it, which is totally against what you're taught as a farmer. You're told to avoid unnecessary risk, certainly in a business sense.'

The loan funded the building of a unit and machinery, and production began in June 2015. It was initially launched in those local farm shops, but vendors in Skipton and Harrogate soon stepped forward, as did Michelin star restaurants. Sam and his small team's passion for the product allowed the business to grow further and in 2016 Hesper Farm skyr was listed in Booths supermarket.

'That was great for us,' Sam said. 'It was a real learning curve; sitting with a supermarket buyer to try and sell our brand. We are still trying to perfect that now. When we initially launched it was big news and we had a lot of support locally. Once you leave the area, the less people know about you and you lose that local brand advantage. You have to think about how you market to new people because the brand hasn't gained traction.

'We based our story on it being a natural product made using authentic techniques and it seems to have worked. There are four of us working here now; when we started production, we made just 100 kilos a week and now it can be up to 1.2 tonnes. The plan in 2020 and beyond was to triple that.'

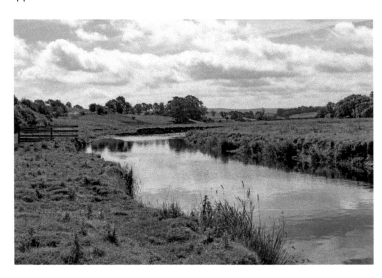

... and the first British farm in the country to make skyr.

DID YOU KNOW?
Skyr is made from skimmed milk, which is warmed before original bio-live Icelandic cultures are added. Once it thickens, the curd is drained overnight using muslin sacks to remove the whey.

In 2019, Sam secured more investment to drive his business forward and landed a listing in local Morrisons branches. Hesper Farm skyr has certainly come a long way since 2015 and shows no sign of being a 'fad'. He admits that the decision to 'bet the farm' on such a project wasn't widely welcomed within the Moorhouse family at first – understandably – but he was always going to make it work.

'I'd decided I was going to do it pretty much from the outset,' he explained. 'I wasn't a partner in the farm when I came back from Iceland and arranged the bank meetings myself. I was driven to do it. I can completely understand where my dad was coming from. He is a very good pedigree farmer and respected all over the country for the quality of the cows he produces. It was a risk for him and probably an unnecessary one. If you went to anyone who runs a dairy farm and said you needed £200,000 to start a farm diversification project that no one has heard of then the natural response would be one of reluctance!

'We obviously got the backing from him as we built the building here, although I am not sure he ever said yes to it! There is a trust there though that we were doing the right thing. I think I have brought him around but even now, even though he likes the skyr and what we make, I think I still need to prove myself!

'I knew there wasn't a margin for error, and I was comfortable with that. It was about whether we did something to try and make us feasible as a long-term business rather than growing into a massive farm. It was more about the cows and being sustainable than

Thorarinn Sveinsson teaching Sam (right)
how to make skyr.

getting bigger. Dad's lifetime work is pedigree breeding and it is difficult to do that, and focus that individual attention on each animal, when it becomes such a bigger scale.

'In the future we would love to take the milk from the farm but at present it isn't workable. We need around 4,000 litres of milk a week to produce what we do now, and that is equivalent to around one day's milking, so it wouldn't work. We couldn't take on the milk processing because of the investment needed for a pasteuriser.

'If we could get to 10,000 litres a week then it is something we could look at, and with the reduction in food miles it would be a really strong story for our brand. Directly taking our own milk secures the price for the farm, which is a good thing, and allows both businesses to be sustainable. Dales Dairies at Grassington does a great job for us, but we are constantly at the whim of the market.

'It is a product-led market and we don't have deep pockets for marketing. For the giants they have the relationship with the retailer and can go and say we have made this, it is the next big thing so trust us, and the supermarkets make room for it. The challenge for us is to get a retailer to trust Hesper as a brand.

'I know the product is very good and we make the best skyr in the country, with quality milk.'

Dent Brewery
In Cumbria, there are currently sixty-four micro-breweries - a huge increase from just two some thirty years ago. That growth has been fuelled by changing drinking habits, the decreasing cost of setting up a small brewery and the subsequent rise in the number of institutions offering brewing courses.

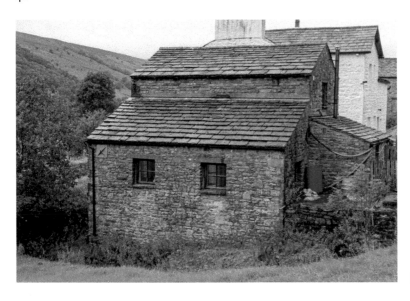

Dent Brewery.

Dent Brewery, which is located just 3 kilometres from Dent in Cowgill, was the third brewery in the county and probably the first in the Yorkshire Dales. Established in 1989 by Martin Stafford, it brewed for the two pubs in the village, the George and Dragon and Sun Inn, and sold its wares wholesale under the name Flying Firkin. In 2005, it was sold to current owners Paul and Judith Beeley and is now under the control of head brewer Keith. It is nestled just a few hundred metres from the River Dee and takes natural spring water to make its superb ales – the only brewery to do so on this side of Yorkshire.

'We've always been on this site,' Keith explains. 'We were a five-barrel plant and a one-storey building originally, but that doubled in 2005. We brew Cumbrian ales, stouts, and bitters as well as golden ales, India Pale Ale (IPA), and session ales. Our recipes are very traditional, but we do try different things depending on the season and conditions. Because of the mix of land we have here – mainly limestone and peat – the water we draw from the spring fluctuates, so we keep an eye on it to decide what we can brew on what day.

'If it has been dry for a while, we know we have good water for the paler beers. If it has been raining, we get the acidity from the peat and we know this is the day for the bests, bitters, and stouts. It is the unique aspect of brewing here and makes the ales taste the way they do.

'We continue to supply to the village and the George and Dragon is our taphouse. We also cover the whole of Cumbria and West Yorkshire. We have sold into Scotland, Manchester, Leeds, Liverpool, and Lancaster too. Our beers have been in the Houses of Parliament, across to Ireland and we have been approached from buyers in Japan in the past, and America.

'It's that unique style that keeps us popular. Other breweries tend to go to really hoppy and use American new world hops, but we try to stay as traditional as possible. There aren't many breweries out there that do that kind of 'flat cap' ale; the sweeter beers like premiums, stout, milds and porters. I do feel the traditional beers are somewhat underrepresented in the market these days.'

Dent Brewery may be small – Keith and his assistant Lauren are the only employees – but it packs a real punch. Its fermenters can produce up to 1,800 litres (that's more than 3,150 pints) per brew per day and run five times a week in summer. Keith says that they've even double-brewed to meet demand. Bottling is done off-site, although they have hand-filled for special orders, while all beers are conditioned in the cask, rather than in tanks. This means the beer is kept in the cask in a cold store for two to three weeks before it goes to market – a traditional process that isn't used as much these days.

'I've been here more than six years now and my role is to focus on brewing, new recipes, quality control and product analysis,' Keith continues. 'Lauren has been amazing since she came here and is my assistant brewer as well as looking after sales, PR and our deliveries. She is a jack of all trades. Being a brewer at a craft brewery is definitely a lifestyle choice. There is a lot of freedom try things that might work and create new beers.

'I'm originally from Leicester but my mum was born in Richmond. I came to Ambleside to do a degree and then went to work at a special educational needs centre until they were taken over. There were other things happening in my life at the time, so I took the opportunity to assess where I was. I always liked home brewing and did so throughout my time at university, so thought it might be an option for me.

'I enrolled on a course which looked at brewing and how to run a commercial operation and I really enjoyed it. The next step was to decide whether I wanted to set up my own brewery or work for another. I thought I could do the latter for a year and learn ... but

More than 3,150 pints of beer can be brewed at the brewery.

then I thought first I had to get a job in such a competitive market. I fell into being a horn craftsman instead.

'I was making bugles and mugs out of rams horn, and I made some props for *Game of Thrones* for a company called Abbey Horn. One night, I randomly bumped into an old university friend and she told me her partner was working at a pub in Cumbria and they were looking for an assistant brewer. I thought why not, applied for it, and ended up working there for a year until the role at Dent came up. I joined as assistant brewer and then became head brewer. It is such a nice place to work, and a great company too, so why would I want to go anywhere else? It's been really good!'

Dent brewed an IPA to celebrate the fiftieth anniversary of the Dales Way and tailored it to be refreshing for those walking the 128-kilometre route. It was supposed to be a one-off but became so popular that is now part of their core range.

'It's had great reviews from pubs and drinkers, and it is fast becoming our most popular beer,' Keith said. 'It was showcased at the Kendal Mountain Festival and we're really proud of it. We want to continue to make great beers and broaden our reach with new customers. Hopefully, we will offer official tours of the brewery soon too.'

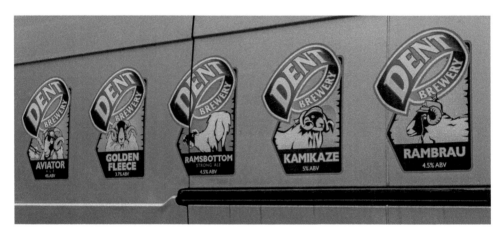

Above: Some of the range.

Left: A pint of Golden Fleece in the George and Dragon at Dent.

5. Pubs

Everyone likes a good pub, don't they? The Dales has several fine inns that have been welcoming wayfarers for hundreds of years. Some were former farmhouses and courthouses whilst others acted as a hub for miners, workers and, yes, teetotallers. Then, there's the former alehouses connected to TV, film and celebrated playwrights and those made famous by commercials.

It is impossible to list all the great inns the Yorkshire Dales has to offer, so here are a few of the author's favourites, for varying reasons!

DID YOU KNOW?
The latest statistics from the British Beer and Pub Association (BBPA) indicate there were 48,350 pubs in the UK in 2017, down more than 10,000 since 2000. However, early indications show that in 2019 there was a net increase of 320 – good news for the industry. Early indications suggested there was a net increase of 320 in 2019 but the coronavirus pandemic would have certainly reversed that trend.

The Falcon Inn, Arncliffe

If there is a pub that rests on tradition, then the Falcon in Arncliffe is it. Modern furnishings are rare; this is a village pub with a history of more than 150 years that provides delicious food and good beer. It sells real ale as standard, of course, but Timothy

The Falcon in Arncliffe ...
the former Woolpack of
Emmerdale fame!

No modern trappings here...

...and beer poured the old-fashioned way!

Taylor's Boltmaker is served from a jug after being drawn from the cask away from the bar. It allows the 4 per cent ABV ale to breathe and reach room temperature, arriving in your glass in the best possible condition.

The pub's exterior was used in ITV's long-running *Emmerdale* until filming moved to Esholt in 1976 – the original 'Woolpack'.

The George Inn, Hubberholme

This Grade II seventeenth-century pub is based in one of the quieter parts of the Dales with the beautiful River Wharfe rolling past. It was built in 1630 as a farmstead and became an inn in 1754. Before that it was a vicarage and that is how it became known locally as 'the candle pub'. When the vicar was home, he would put a lit candle in the window to signal to his parishioners that they could come and see him. That custom continued when it became a pub and the current landlords still have a lit candle on the bar. Quite simply, when the candle is burning, the pub is open.

It is easy to see why this pub attracts visitors from all over the Dales and beyond. Prolific writer and playwright J. B. Priestley frequented the village – and the inn – and called it the 'pleasantest place in the world'. In the snug, near the bar, is a corner dedicated to him.

The candle is lit – the George is open.

There's also an annual land-letting ceremony that it hosts for the village. The Hubberholme Parliament meets each year to auction 16 acres (6.5 hectares) of pasture that was bequeathed to the parish back in the early nineteenth century.

Taking place on the first Monday in January, a service is held at the village church to celebrate the forthcoming land-letting and then the vicar comes across to the pub with his wardens. Tradition says he must ask the landlord if he has prepared the candle and once it is lit, the auction begins. Anyone can bid for the land and when the candle goes out, whoever has the highest bid wins and hands the money over to the church.

They gain the rights to graze the land whilst the church shares out the money to the poor in the parish. Traditionally, it has raised around £350 but it can go for well over £1,000 at times. It is fair to say it isn't a lucrative commercial venture for the winner; it is a part of tradition and history, and helps those who need it in the parish.

The Green Dragon Inn, Hardraw

Until 2018, access to the wonderful Hardraw Force – the highest single-drop waterfall in England at 30 metres – was through The Green Dragon.

A simple trip through the thirteenth-century bar allowed you to walk to the amphitheatre created by the 'force' as it falls unbroken over carboniferous limestone, sandstone and then shale before plunging into a large pool. Now, visitors have to head to the heritage centre next door to see the waterfall, and if it is closed, pay a small fee to pass through a turnstile.

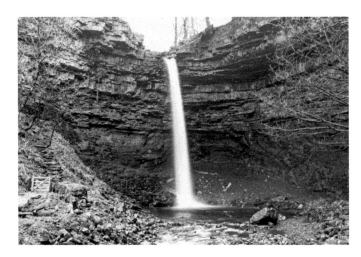

Hardraw Force, the highest single-drop waterfall in England.

It is a shame as the pub is well worth a visit and the two will always be interlinked in many people's memories. 'Hardraw' comes from the Old English for 'shepherds dwelling' and the land was once owned by Cistercian monks who kept a grange in the village. The early northern (Yorkist) kings would rally their troops at known locations such as 'at the banner of the Green Dragon' near the waterfall. It is possible this is the origin of the inn's name and the pub's sign does show a green dragon and white rose.

Inside, it is a cracker with flagged floors, open fires, beamed ceilings and stone walls. A priests' hiding hole was reportedly found in the 1970s above the former bar and kitchen area. Apparently, it led to the graveyard next door, but it is now filled in.

DID YOU KNOW?
Hardraw Force was famously used by Kevin Costner's 'bum' double in the film *Robin Hood: Prince of Thieves*, when Maid Marian catches Robin bathing under a waterfall.

The Tan Hill Inn, near Reeth

The Tan Hill is England's highest pub at 528 metres above sea level and dates back to the seventeenth century. It is on the Pennine Way and a sanctuary for those walking one of the most remote sections of the 430-kilometre walk. It is infamous for its punters being snowed in during the winter and not being able to leave until the thaw sets in. Provisions are said to have run incredibly low sometimes, and weary patrons often leave the pub to widespread media interest – and no doubt seeking a hangover cure!

The pub stands on several historic packhorse and drovers' routes into the Dales and a coal field that was exploited in the fourteenth century and once fed Richmond Castle. The pub was used by those miners (pre-hostelry it was used as a makeshift mortuary for local

Tan Hill is the highest pub in England.

mining fatalities) and continued to be popular even after the last mine closed in 1929. Now, its porch is always open for those who need shelter, and the fire has never gone out in more than 100 years.

There have been several famous visitors over the years too. The Arctic Monkeys and Scouting for Girls have played there, BBC's Elle Harrison sung 'Ring of Fire' for *Countryfile* and Richard Hammond filmed *Top Gear* at the pub too. It has also been the site of film and programme makers wanting a remote and unique location while Ted Moult and his famous double-glazing Everest ads had been filmed there in the 1980s.

The fire has never gone out...

The Cross Keys, near Cautley Spout

At the base of the stunning Cautley Spout is the Cross Keys, a 400-year-old inn with a fascinating past. It is currently a National Trust temperance inn, serving food in an iconic location. Early records suggest that it was built in the late sixteenth century with later extensions being made in the eighteenth and nineteenth centuries. In the 1800s, it was a farmhouse known as High Haygarth, with its transition to becoming an inn coming some twenty years later when the Cautley road was realigned to run past the farm - the occupants taking advantage of increased passing trade.

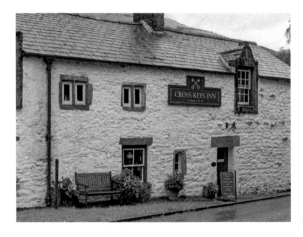

Cross Keys Temperance Inn...

...is more than 400 years old.

It was bought by Mrs Sarah Buck of Ravenstonedale in 1902, who paid £900, and she duly sold it on to Edith Adelaide Bunney who, promptly removed the alcohol licence. It remained with her until 1949, when she passed it to the National Trust to be held as an unlicensed inn, in memory of her sister Mary Blanche Hewetson.

You can drink alcohol in Cross Keys – you must bring your own – but it is the food that makes it a real destination. It is traditional Yorkshire fayre, cooked well, and you can take on a 'crundle' – a traditional Westmorland dish made of enriched egg batter, served with stewed fruit.

The Victoria Arms, Worton

Many country pubs aspire to be traditional with some managing to look like the hostelries of yesteryear more easily than others. Wood panelling, open fires, and hand-pulled ales all add to the experience, but there's a difference between something that is old, and something pretending to be.

The Victoria shuns all that because, quite simply, it hasn't changed in decades. From its aging facia to the old interior, it's what a pub would have been like before they all had to start serving food and supply snacks other than pork scratchings. Before 1960, the pub didn't have a bar and the room on the left was a barn.

The Campaign for Real Ale (CAMRA) says, 'Like no other pub in the Dales these days and, for its basic unpretentiousness, perhaps the nearest approximation to how they once were.'

They're right too.

Like no other pub in the Dales according to CAMRA.

The Craven Arms, Appletreewick

Now here is a pub that looks old ... because it is!

It dates to the sixteenth century and was part of Sir William Craven's estate. He was the Lord Mayor of London in 1610 and was born to a pauper's family in this small hamlet. It is suggested he was the inspiration behind some versions of the folk tale Dick Whittington – although the tale heralds from well before William was given the title.

He did play a huge role in the area: on his return from London he enlarged the High Hall, constructed the road from Appletreewick to Burnsall, built Burnsall Bridge and Burnsall School and repaired St Wilfrid's Church.

The pub has his coat of arms on the front as well as original fireplaces, low-beamed ceilings, and stone-flagged floors. Originally, it was a farmhouse and 'grew' into a pub because the occupant was brewing ale and selling it to passers-by.

Power is supplied via gas, and you can see the lights at the entrance flickering as a result. Up until 1926, the Court Leet was held at the pub, dealing with petty crimes, and the village stocks are to the left of the building.

Out the back is a Cruck Barn – the first of its kind to be built in the Dales for around 400 years. It was constructed by Robert Aynesworth, a member of the family who owns the Craven. He built it utilising the same traditional methods and it has a beam from the High Hall, alongside a heather-thatched roof, lime, and horsehair plaster, limewash and a huge log fire with sheep wool insulation. It is used for weddings, parties, and other such events like annual ferret-racing competitions, when the place is absolutely full of folk ... and furry animals!

Annual ferret racing at the Craven Arms. (Johnny Hartnell)

6. Notable Folk

Over its history, the Dales has welcomed and been home to several people who have gone on to become household names in their field. Maybe it's the fresh air, rolling hills or something in the water, but the area has had its fair share of famous folk. Here are some of the more notable visitors and inhabitants.

A Note

Of course, this list isn't exhaustive. Some of the people featured in this book already are more than notable. Jason Mallinson and John Cordingley are leaders in their caving fields whilst there is no better historian in the region than Dr David Johnson. Then there's David Joy MBE, the author of more than fifty books, Neil Heseltine and so forth.

William Armstrong (1810–1900)

William was an English engineer who founded the Armstrong Whitworth company on Teesside. It built ships, locomotives, cars, and aircraft as well as armaments before merging with Vickers to form Vickers-Armstrongs (now Vickers).

Whilst visiting the Dales on honeymoon and fishing on the River Dee in 1830, he noted the way the paddle wheel worked at Arten Gill and thought it was an inefficient process, losing most of the available power created by the water. He made some notes, returned home, and designed a rotary engine – effectively the world's first turbine. It picked up little interest, but he would use the idea to develop a piston engine instead, suitable for driving hydraulics.

Kit Calvert (1904–84)

As well as being the saviour of Wensleydale cheese, Kit was a true Dalesman whose achievements show his love of the area.

He was a quarryman's son who became a labourer at twelve years old, before he made his intervention in 1935 to turn Wensleydale Creamery into a co-operative and then sell it to the Milk Marketing Board. He also opened a second-hand bookshop, with honesty box, and was a local preacher too who translated parts of the Bible into local dialect.

Lady Anne Clifford (1590–1676)

Lady Anne was born in Skipton Castle on 30 January 1590. She inherited her barony in 1605 and became the fourteenth Baroness of Clifford. She was a patron of literature owing to her writing and made several improvements to her family's properties across the Dales, many of which can be seen today.

She restored churches at Appleby and Mallerstang for example, as well as the castles at Skipton (rebuilt after the Civil War of 1645), Brough and Pendragon. A yew tree planted at

Lady Ann Clifford restored Skipton Castle after the Civil War of 1645. A yew tree planted in the courtyard to mark the works still grows.

Skipton to signal her development still grows in the courtyard and is impressive when in blossom. She died, aged eighty-six, at Brougham Castle, and her tomb and monument are in St Lawrence's Church in Appleby.

John Delaney (1846–1921)

John was an Irishman who, after fleeing the potato famine, found himself working at a mill in Settle. From there, he launched his own coal business with a horse and cart, and then progressed to selling lime. Some 1,000 railway wagons would eventually bear his name.

When he returned from studying geology at university, he began to include quarrying in his enterprises. Amongst his business empire, he had a site near Horton-in-Ribblesdale and a large one at Threshfield in Wharfedale.

Writer W. R. Mitchell wrote in the *Craven Herald* that John would arrange for water to be collected from a spring in Beecroft Quarry at Horton each day and delivered to Settle. He preferred this water to the supply that gushed from the local taps.

The Farrers of Clapham

Probably the most significant role played in the development of Clapham as a small village with a real community heartbeat is that of the Farrer family. They established Ingleborough Estate in the eighteenth century and are responsible for the woods, fields, moors, farms, village hall, and play areas of the village, as well as the stunning Nature Trail. They also started social policies to ensure local families could live in the village through affordable rents.

Reginald Farrer was a world-renowned botanist who, from his birth in 1880 to his death forty years later, loved landscape, exotic plants, and travel. When he returned from his trips, he would plant seeds and botanical species in the family's grounds.

He was drawn to alpines, shrubs, and other plants that he would find in China, Tibet, and Burma. They would be transferred back to England and planted on the estate, surviving because the soil was acidic. Worried that they might not grow as well they should, or replicate the ones from his travels, he would load seeds into his shotgun and

The Farrers had a big influence on Clapham.

fire them into the cliffs in the grounds to recreate their environs. You can see his work on the Nature Trail in the village which was opened in 1970 to celebrate his life, contribution to the village and European Conservation Year. The walk features an artificial lake which provided power to streetlights, hydroelectrically, and supplied water to the village.

Dr John Farrer passed away in 2014 at the age of ninety-three, and up until the time of his death was active in managing the estate. Australian by birth, he came to the area in 1953 when he was told of his uncle Roland Farrer's passing. He transformed the estate's books and did much of the handiwork as well as continuing to practice as a doctor until he was seventy. He was also Governor of Clapham School for more than fifty years, supported Cave Rescue, administered permits to visit caves on the estate and was warden at the church.

DID YOU KNOW?
A member of the Farrer family walked from Clapham to London in 1760 ... no mean feat at around 400 kilometres!

Mike Harding (b. 1944)

Mike grew up in Crumpsall in Manchester but has lived in the Dales since 1971.

They say you are never a Dalesman until you have three generations or more in the graveyard. Here I think we can make an exception. Mike is a broadcaster, folk music aficionado, advocate of nature, fishing expert, author and former Ramblers president as well as being a mainstay at the BBC as a stand-up comic and radio presenter. He once sat on what he claimed was a stuffed Alsatian on *Top of the Pops* to sing 'Rochdale Cowboy'.

Above all, he is a massive advocate for the Dales and its preservation.

Mike Harding.

Alastair Humphreys (b. 1976)

Originally from Airton, near Malham, Alastair is an adventurer whose passion for the outdoors began at age of nine when he completed the Yorkshire Three Peaks Challenge and explored the landscape around his home. It stirred the passions for him to complete several other adventures before spending more than four years cycling round the world, a journey of 46,000 miles through sixty countries and five continents.

More recently, he walked across southern India, rowed across the Atlantic Ocean, ran six marathons through the Sahara Desert, completed a crossing of Iceland, busked through Spain (following in the footsteps of Laurie Lee) and participated in an expedition in the Arctic, close to the magnetic North Pole. It's these sorts of adventures that saw him named as one of National Geographic's Adventurers of the Year in 2012.

He now 'adventures' close to home, being the man behind the micro-adventure movement which encourages people to undertake small adventures such as spending a night in the woods or enjoying a dip in a local river.

Richard and Cherry Kearton (1862–1928 and 1871–1927)

The Kearton brothers were pioneering ornithologists who, although born in Thwaite, were educated in Muker. They were masters in photographing animals in the wild and in 1895 produced the first natural history book to be entirely illustrated by wild photographs.

Cherry, who in 1892 took the first ever picture of a bird's nest containing eggs, went on to become a wildlife filmmaker. The Royal Geographical Society created the Cherry Kearton Medal and Award in his honour. He was a friend to Theodore Roosevelt.

Fred Lawson (1888–1968)

Fred was a noted artist who lived at Castle Bolton for fifty years. His speciality was painting outdoors, with buildings and landscape featuring predominantly.

W. R. Mitchell (1928–2015)

Alongside being an editor of the esteemed *Dalesman* magazine for twenty years, Mitchell wrote more than 200 books and was an authority on the evolution of this area. He was

born in Skipton and was a Methodist preacher for more than forty years. His work featured the social changes in the Dales through time, but he also had a keen focus on nature and the natural landscape.

Many Dales authors still use his work as a basis and the fact he recorded most of his interviews on tape is a vital resource. They are held in the University of Leeds (Special Collections) library, with the W. R. Mitchell Archive now being digitised by Settle Stories.

Amanda Owen (b. 1975)

Amanda is one of the most prominent people in the Dales to bring farming and its realities into the homes of the country. She first appeared on ITV's *The Dales* with Adrian Edmondson before starring in Ben Fogle's *New Lives in the Wild* and Channel 5's four-part documentary series *Our Yorkshire Farm*, all featuring her family (nine children!) and life at Ravenseat Farm. She's written three best-selling books about her life, and it's her brutal honesty that makes them popular. Her social media accounts are must follows too (search Yorkshire Shepherdess on Twitter and Instagram). There's no sugar-coating here!

J. B. Priestley (1894–1984)

The famous playwright and novelist called Hubberholme the 'pleasantest place in the world'. His ashes are interned in St Michael and All Angels Church, which dates to the twelfth century. Priestley frequented the George Inn on several occasions and the snug in the main area pays homage to him.

Priestley frequented the George Inn on several occasions and the snug pays homage to him.

Arthur Raistrick (1896–1991)

Raistrick was a leading geologist and historian who specialised in the Craven area of the Dales, particularly around his home at Linton near Grassington. He was an industrial archaeologist and published more than 300 articles and books, one of which, *Industrial Archaeology*, is still very much a staple today. He was born in Saltaire.

Adam Sedgwick (1785–1873)

A founder of modern geology, Adam was born in Dent and held it close to his heart. He proposed the Devonian and Cambrian periods of timescale and worked with the young Charles Darwin in his early study of geology.

His biographer Colin Speakman said, 'He was a great geologist; described as one of the world's greatest field geologists who discovered the Cambrian system and described the Dent Fault, but also was a brilliant teacher, taught Charles Darwin, and also one of the first great teachers to introduce women to university lectures in Cambridge. He was a great personality.'

He was also real statesman, relaying Wellington's victory at Waterloo to the village after he picked up the news in nearby Sedbergh. Although he spent most of his life in Cambridge and Norwich, the Dales was his spiritual focal point and his writings depict life in Dentdale and the social changes it underwent, particularly as making a living from yeoman farming and knitting became more difficult. That time away from the Dales didn't dampen the spirits of the village he enjoyed his formative years in.

Adam Sedgwick's memorial in Dent.

'Sedgwick talked of Dent not having the buzz of the spinning wheel and hum of the songs … no places of mirth and glee,' Speakman wrote.

There is a fountain made of Shap granite in the centre of Dent – a real symbol of his character and how much esteem he was held in. Originally, it didn't have the dates of his life, because everyone knew who he was. They were added later.

Colin Speakman (b. 1941)

Colin was integral in creating the Dales Way, a long-distance footpath of 128 kilometres running from Ilkley to Bowness. He is a prolific author and champion of access via public transport in the Dales.

'In 1968, the Countryside Act gave local authorities new powers to create public access to riversides,' he said. 'In the West Riding area of the Ramblers' Association, we saw it as a heaven-sent opportunity to create a new route. After some discussion with the senior planning officers of the old West Riding County Council it was agreed that our priority would be to follow the River Wharfe, which linked Ilkley to the Yorkshire Dales National Park.

'The walk from Ilkley to the source of the Wharfe on Cam Fell would end in the middle of nowhere, so we took the opportunity to continue across the watershed, down another fine valley and follow the River Dee through Dentdale and then via Sedbergh and the River Lune to the national park boundary at Crook of Lune bridge. Even this didn't make sense when we could see, so very close, the Lakeland Hills. So, we decided to take it through what was Westmorland to the end of Lake Windermere.

'It was inspired by Tom Stephenson's Pennine Way, but much different being mostly a riverside walk through sheltered dales with plenty of places to stay in attractive villages. We hoped to create awareness of the remarkable heritage of definitive rights of way, newly established and available for everyone to enjoy as well as our recent designated National Parks.'

Colin approached the statutory bodies, who agreed that whilst it was an innovative idea, creating such a route wasn't a priority. Undeterred, the ramblers took it into their own hands to prove that 'people, not bureaucrats' create paths.

'The public would decide if they wanted to walk it,' he continued, 'and over the next fifty years or so they did in their thousands. Dales way become a true people's path – a national trail in all but official designation.'

On 10 March 1969 a newspaper article asked for people to walk the new route saying, 'If you are interested, if you have a longing for fresh air after this long dark winter of discontent, now is the time to polish your best walking boots and get out your rucksack.' It said would-be walkers should meet at Ilkley post office on Sunday 23 March, at 10.15 a.m., to walk the first 10 miles (16 kilometres) of the new route. In the end, Colin led more than 130 walkers on a 12-mile (19-kilometre) route before they caught a bus back to the start point. This historic walk has been celebrated every decade since.

The first recorded completion of the route was by Venture Scouts from Bradford Grammar School who did it in three-and-a-half days.

Colin Speakman at the seat on the Dales Way. (Tony Grogan)

DID YOU KNOW?
'Dee' is the Celtic word for brown trout.

Halliwell Sutcliffe (1870–1932)

Sutcliffe was a popular novelist, specialising in historical romances set in the Yorkshire Dales. Many of them feature the Stuarts, especially Bonnie Prince Charlie. He died in Linton in 1932.

7. Folk Tales

Everyone enjoys a good story, don't they? The superstitious anecdote passed down through generations, the tale of odd sightings and even odder people, the explanation of a festival; each has their own particular history and folklore.

Usually, these tales have been exaggerated beyond their original basis but as the adage says, where's there's smoke there's fire....

Austwick

This small village in the southern Dales features in a fair share of stories – and not all of them are entirely complimentary.

Firstly, we have the Cuckoo of Austwick. Winters in the Dales can be particularly harsh, so any sign of spring and better weather ahead is naturally a source of joy to embattled residents who have had to layer up in the colder times. The cuckoo is seen as a sign that those warmer times are coming, and the people of Austwick were so pleased to see one nesting in a tree that they built a wall around it in the hope of keeping it there. They believed if the bird stayed in the village that they could keep the balmy temperatures all-year round. Sadly, the wall they constructed wasn't high enough to keep the cuckoo in the village and it simply flew away. The story is celebrated in the village's Cuckoo Festival in May each year.

Then there's the story that contains a lot of bull ... a big one to be precise. I am not sure this is a specifically an Austwick-only story, but it seems to have stuck with the village. A farmer wanted to move a bull out of his field and so enlisted the help of nine of his friends to give him a hand in lifting it over the gate (or wall).

They sweated, grunted, and grafted for a good few hours before they gave up and sent one of the group to the village for more help. He opened the gate and off he went. After much head-scratching the problem was solved...

There's another tale about the village's only knife, which was lost after a workman, looking for a safe place to hide it so it could be used the next day, stuck it in the ground under a black cloud as that was the most obvious landmark. When he returned the next day, he couldn't find it.

And there is a story of a local man who fell into a deep pool. Instead of trying to get out he said it would be better at the bottom and sank. His friends did the same and that was the end of them all.

The Dent Vampire!

I have lost count of the number of times I have been told about the infamous Dent Vampire. I spent a lot of my younger years in the village and barely a visit went by without some recounting of the tale – probably to scare my naive heart.

Here lies the
Dent vampire.

Outside the porch of St Andrew's Church, which was built in the twelfth century, is the gravestone of George Hodgson. He died in 1715, aged ninety-four (quite impressive for those times), but subsequently started to make regular appearances around the village. Even before he passed away rumour spread through the village that he downed a daily glass of sheep's blood as a tonic, which might have positively affected his longevity. But it was when a farmer said he had shot a black hare and followed the blood trail which led to George's door, that panic spread. On looking through the window he saw Mr Hodgson tending a shotgun wound.

Worried, villagers exhumed his body, dug a new grave at at the door of the church and drove a brass stake through his body. You can still see the top of that 'stake' in the upper part of the gravestone too.

However, if you don't want the mystery spoilt, then look away now. The remains of the stake are nothing more than what's left of the brass plaque which had been attached to the stone.

The Lake of Hull Pot ... or Hull Pot Lake

On the wall of the Crown Inn in Horton is a picture of Hull Pot, nearly filled to the top after a heavy downfall, with gamekeeper George Perfect stood next to it.

The pothole can be found at the foot of Pen-y-Ghent, on the Pennine Way, and is an iconic landmark for those people walking the long-distance path or undertaking the Three Peaks Challenge via the traditional route. The impressive open pot is 18 metres deep, 90 metres in length, and well worth a visit whatever the weather.

In March 2019, Horton local Roger Pilkington thought a trip up the long lane from the village would be worth it too. He wondered whether the rumours of the pot overflowing in severe weather would be true. He'd seen the picture in the Crown and curiosity got the better of him.

'It had been raining really hard,' he said. 'The river had burst its banks and flooded the road opposite my house. Cars and trucks were getting towed out of the water and as I watched them, I remembered the picture in the Crown.

'I thought if there ever was going to be a time to see if it looked the same, then this was the day. It took a lot of persuasion to get my almost teenage daughter to come up with me, and I told her it was a 1-mile walk to get to the pot, when it was probably more like 2, in dreadful conditions!

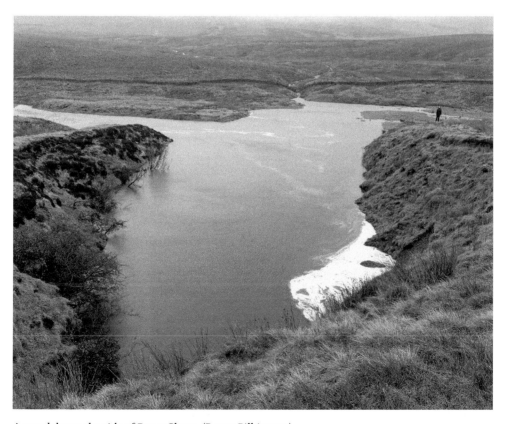

A new lake on the side of Pen-y-Ghent. (Roger Pilkington)

In dryer conditions. (Roger Pilkington)

'Thankfully, she agreed, and it was worth it. When you got close, you could see that there wasn't a pot anymore, just a massive lake. We didn't realise at first, but while we were there, taking a couple of photos, it had just started to overflow down the path we had walked up.

'Twenty years ago, I scrambled down into the open pot with my brother, so to see it full was really special – and I realised my daughter and I were probably the only people who saw it overflowing like that. When other people saw it, a couple of hours afterwards, it was half full. That shows the drainage underneath. So impressive.'

DID YOU KNOW?
Although it isn't rectangular, it is possible to estimate how much water was in Hull Pot on 17 March 2019. The volume would have been just short of 29,160,000 litres of water - or, as Roger put it, 1,000 milk tankers or more!

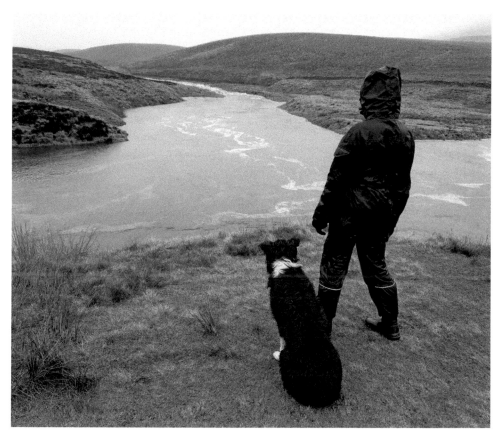

The amount of water in this pothole is staggering. (Roger Pilkington)

Does It Ebb or Flow?

Giggleswick Scar is one of the most dramatic landscapes in the Dales. The cliffs rise quickly on one side, thanks to the actions of the South Craven Fault, with the opposite land falling away.

If you travel down the B5480 towards Settle, you can see this geological contrast in stark reality. The limestone shoots up on your left, whilst there is a featureless landscape on your right. In fact, you would have to go a long way down to find the same rock that is so evident on the opposite side of the road.

Nestled on this route, 1.5 kilometres outside of Giggleswick, is a well which seems have harnessed this geology to create a real wonder. It's not an easy place to park and get to, nor is the walk from the small lay-by a few hundred metres down the road one for the faint-hearted when there are cars whizzing past, but should you see 'ebb and flow' then you are truly blessed.

In the nineteenth century, it was reported that the water would rise by 8 inches (some 20 centimetres), creating a real highlight to the visitors who would seek it out. More than two centuries earlier, William Camden wrote in *Britannia* that it was 'the most noted spring in England for ebbing and flowing, sometimes thrice an hour'.

DID YOU KNOW?
A folk tale says that a nymph was chased through the woods at Giggleswick by a satyr. She prayed to the gods for her protection and they duly transformed her into the water source that now flows to this well.

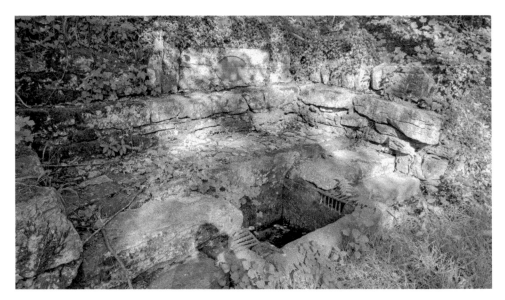

Does it ebb...or flow...or neither!

That ebb and flow is somewhat limited now as sediment has built up in the siphon passage that takes the water to the well. It seems to have been like that for a while too – although there are still people who claim to have seen it in action after heavy rain.

Wainwright in *Walks in Limestone Country* said,

In its heyday, much was written about it, both in prose and verse. But today its performances are meagre and the few people who have witnessed the ebb and flow are themselves becoming unique, while those who have watched the well for hours without anything happening are numbered in legions.

Good luck!

Something's Fishy...

The Dales has loads of great caves, so why should this one be special? We've already looked at underground exploration, but the caverns still have their fair share of folklore. Yordas Cave in Kingsdale, for instance, was named after a Nordic giant who liked hunting small children and eating them in the cave.

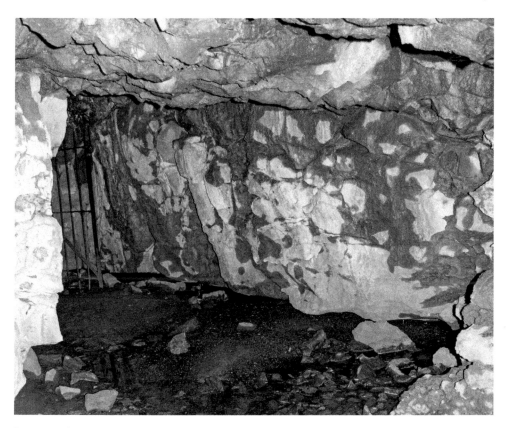

Bruntscar Cave.

Bruntscar Cave was discovered in 1865 when Bruntscar Hall owner Francis Kidd heard a large rush of water below his house. Armed with a hammer and a pick he uncovered the source of the noise and unveiled the entrance to a superb cave, right up against his barn.

If finding your very own cave wasn't enough then it seems it was also home to a very tame trout called Dick. Francis would feed it beef and mutton with one hand and give it bit of a tickle with his other. They grew quite attached to each other until one day the trout was nowhere to be seen.

It seems Dick had been accidentally scooped up by a local girl in her water bucket, but it was only when the water was put over the fire that he reappeared, leaping out onto the rug! Who knew fish were that clever? He apparently lived to the ripe old age of sixteen.

Semerwater Rise

Semerwater is the second largest natural lake in Yorkshire after Malham Tarn and is around 800 metres long. Legend says it was once a prosperous city in the Dales, until it flooded.

An old man came into the city in search of somewhere to stay. He knocked on each door, being rebuked every time, before he found a welcoming house where a poor couple took him in. After enjoying their hospitality, he turned to face the city and said, 'Semerwater

Semerwater – is it covering a once prosperous city?

rise! Semerwater sink! And swallow the town, all save this house, where they gave me meat and drink.'

The lake rose, drowned the city's citizens but saved the couple and their house.

The lake is also the site of three large granite stones known as the Carlow and Mermaid Stones – and these have a tale too. A giant on Addlebrough threw stones at the Devil on neighbouring Crag Hill. The Carlow Stone is one that was dropped by the giant.

Never Work with Animals...

Have you heard of the Barguest? It is a monstrous black dog with fierce teeth and claws that stalks folk at Troller's Gill in Wharfedale. Come to think of it, that might be a place to avoid as the caves in the gill also house trolls!

Man's best friend also appears in the folk tale of Devil's Bridge in Kirkby Lonsdale, and others that have the same name across the Dales. The Devil appeared to an old woman, promising to build a bridge over the river for the first soul that crossed over it. She agreed and when it was finished, she threw food over it knowing her dog would cross the bridge and outwit the Devil.

One of the upland fields at Pinhaw Beacon in Lothersdale, near Skipton, is called Swine Harrie. It is reference to a local man who stole a pig and met a tragic end. He whipped it away from a local farmer and crossed the field with it on the end of a long rope. The beast couldn't climb the stile to get out of the pasture, obviously, so the thief put it onto a small platform before he could descend to the other side to help it down. The rope was a bit of pain though, so he wrapped it around his body.

The swine, not being best pleased with being halfway up a wall, panicked and slipped, thus tightening the rope around the man's neck and body – and its own.

Beware of the Barguest at Troller's Gill.
(Bernd Brueggemann / Shutterstock.com)

A Lost Love

In Coverdale, which is in the far east of the Dales, there's the tale of Courting Wall Corner, a place no local would visit because they would see a ghostly figure of a mourning woman with a long black cloak who would shake her head in anguish. The story is based on a local girl who had to choose between two men and then elope to avoid scandal. The rejected chap learned of her plans and duly killed and buried her on the moor, near Courting Wall Corner.

To add weight to the story, peat cutters found a skeleton nearby wearing black clothes.

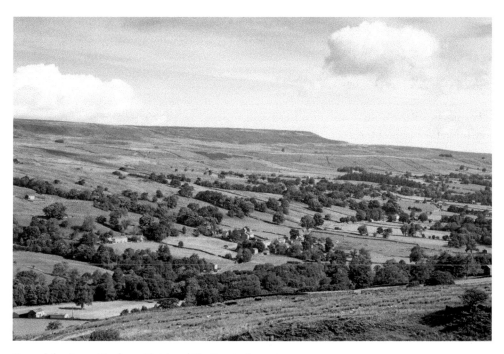

Coverdale views. (Andrew Fletcher / Shutterstock.com)

8. The Old Ways

Packhorse bridge at Dent Viaduct.

Visitors to the Dales have become accustomed to well-prepared paths that can take them to many superb places across the national park. We take them for granted, probably failing to understand the cost of keeping them in great condition and how, especially on the more frequent routes, the chances of becoming lost are virtually impossible.

Many of these can be traced back hundreds, if not thousands, of years, well before they were used for pleasure. The Dales has a fascinating network of old drovers and packhorse tracks that link villages to important trading areas and other areas in the country. The area also has a Roman influence, with Cam Road stretching to Bainbridge, its fort and beyond.

Craven Way

We'll start first with this old packhorse track that connected Dentdale to Ingleton and other routes. The best way to approach it is from Ibbeth Peril, near Cowgill, as the way from Dent itself is fairly laborious. There is a sizeable parking area at Ibbeth Peril, which is an extensive cave system set in the River Dee.

The view to Dentdale on the way up to the Craven Way.

Follow the route from Ribblehead to Dent and after you reach the turn-off for Dent station, the parking area is around a kilometre on your left. Your route is across the river on a footbridge that says 'welcome to flat earth', through the wildflower meadow and turning right along the route until you reach the Dales Way at Laithbank. Then, you follow the path out of the farm and up the hill to the Dales High Way, which eventually becomes the Craven Way.

The route here climbs steadily to Wold End before you reach Great Wold – a ridge of firm limestone which has also been noted as Craven's Wath or Little Craven Wald. On this track is Horse Well, which indicates it was a path used by horses, and a number of springs. The further you progress, the feeling of isolation is strong; the route is underused and that's a blessing as it isn't selfish in the slightest to enjoy the panoramic views. There are fossils in tracks at Duncan Sike Foot, small caves and refreshing springs. Further towards Whernside, Dent Head Viaduct comes into view as the descent is made to Ribblehead, and you can see all the famous three peaks in one vista.

This would have been an impressive walk for the drovers taking their wares onwards to Ingleton ... but an exposed one. Travellers heading the opposite way would have found the route into Dentdale and then picked up the packhorse route to Frostrow before arriving at Sedbergh.

Above and below: On the Craven Way.

Prehistoric cup marks at Cold Cote Gill. (Dr David Johnson)

Corpse Road

For many hundreds of years, the only consecrated ground to bury your dead in Swaledale was in Grinton. If your loved one had passed away, then you needed to take the body to be interred in that churchyard or their soul would be damned for eternity. That meant carrying your deceased in a wicker coffin for several kilometres over some very harsh terrain. These routes became known as Corpse Road or Corpse Ways and can still be walked today.

Starting at Keld, you can join the route that goes over Kisdon Hill before it descends to Muker. The 'way' soon becomes a soft green lane, heading though an area of shakeholes and a lot of obvious mining activity. The track has broken walls at either side, and you can see a barrel-guarded mine entrance alongside other disused shafts, tips, and spoil.

The Corpse Road from Keld to Muker.

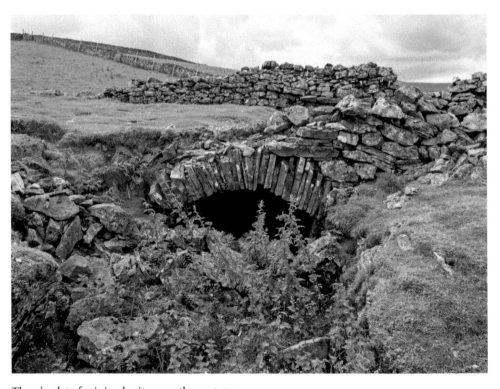

There's a lot of mining heritage on the route too.

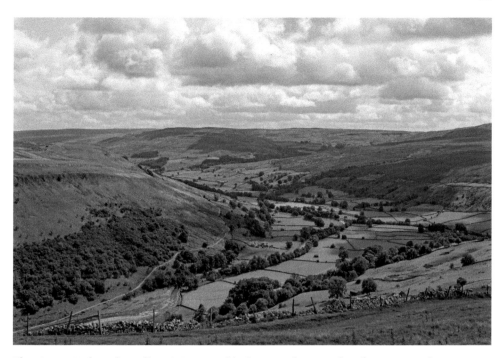

The view to Muker. The walk to Grinton could take more than two days for some people.

Ivelet Bridge.

The purple-tinged waters of the River Swale.

Can you see the coffin stone?

Reaching the top, the route to Muker is a long descent but a scenic one, and from the village, the Corpse Road would have continued its journey via a path running alongside the River Swale.

At Ivelet Bridge, an attractive single-span bridge built in the seventeenth century, is a coffin stone – a large flat stone set in the corner. It is one of a number that were set on the route to allow pall-bearers the chance to rest the coffin so they could take some ease. They would then have continued onwards to Low Row where corpses would be left in the 'dead house' above The Punch Bowl inn whilst mourners rested. It would have been a two-day walk or more for some. In 1580, ground was consecrated at Muker, so they didn't need to make the journey anymore.

Just shy of 2 kilometres from Low Row are the remains of an enclosure on the summit of an isolated hill called How Hill. It is thought to be a prehistoric settlement. Further up the road is a Maiden Castle, probably from the Iron Age. It is a large hillside enclosure with a 2–4-metre ditch. There is a single entrance on the east side too.

Romans

The Roman influence on Britain may be heavily seen in places like Chester and Bath, but their impact on places like the Yorkshire Dales shouldn't go unnoted.

The route that goes across Cam Fell to the Virosidum fort in Bainbridge is likely to have been part of a 32-kilometre road that ran from Ingleton to the fort of Verteris at Brough. It possibly started just outside High Bentham, which would add a further 3 kilometres to its length. From there, the route would have probably continued to Carlisle.

Cam High Road...straight and direct.

Virosidum from above. (Andy Kay / Yorkshire Dales National Park Authority)

Cam High Road leaves the B6255 after Gearstones near Ribblehead and then goes over the top past Cam Fell, Fleet Moss and Dodd Fell before passing Wether Fell and heading in a straight line to Bainbridge. The engineering required to build this road is clearly special and you can still see its camber. It carried soldiers and supplies right into the heart of the Dales and the fort at Bainbridge which was in use for 400 years until AD 410. Groundwork still survives on the glacial mound Virosidum occupied – and you can see why the Romans built a fort there. It had good all-round views.

Virosidum was around 91 by 111 metres and would have been 1 hectare in size. It had several ditches as defence positions – two on the north, one at the south and five on the west. It also held a headquarters, granary, and barracks.

Yorkshire Dales National Park historians say at the east was an annexe for more troops. It was defended by a stone wall which has been identified as the 'bracchium caementicium' (stone-built outwork) built when Alfenus Senecio was governor of the Province of Britain (AD 205–8). 'This was recorded on a dedication slab discovered at Bainbridge some time before AD 1600 but since lost,' records say.

No part of the Ingleton side of the route remains and the notion that it stretched into Bentham is only a theory at best. This part of the road was resurfaced and became part of the Richmond to Lancaster turnpike in the eighteenth century. However, there is a settlement of 'huts and enclosures, with traces of contemporary fields to the north-east and south-west', on Oddies Lane, which is part of the Roman route near Twisleton.

The national park states that 'the remains are well defined, consisting of collapsed rubble walls of some 0.7 metres–1.3 metres in height; now turf covered. The extant remains have similarities in construction, plan and topographical situation to other settlements in this region which have been dated as Iron Age/Romano-British.'

The view from a likely Roman road that went to Low Borrowbridge near Tebay.

Roman milestone at Middleton. (Andy Kay / Yorkshire Dales National Park Authority)

Fairmile Road in Sedbergh has signs of another short piece of Roman road. It is part of a route that ran from Ribchester fort to Tebay. To see it, take the turn beside the Dalesman pub into Howgill Lane. After 8 kilometres, the embanked Roman road is seen on the right for around 400 metres. Continuing along this road you can enjoy greats views of the Westmorland Dales before passing the Roman fort at Low Borrowbridge on your left.

Elsewhere, there is a milestone in Middleton that was moved to the churchyard from a nearby hillside, remains of a villa at Gargrave on the road to Skipton and an extensive field system and settlement at Barbon Park near Barbon.

Monastic Routes

Monks also used ancient routes to connect their large portions of land in the Dales. Cistercian monks owned huge estates in the thirteenth and fourteenth centuries after being donated land by nobles in return for a place in Heaven.

Mastiles Lane, around 5 kilometres to the north-west of Malham, was once part of a route which linked up the estates of Fountains Abbey in the Lake District to the 'main' site in Nidderdale. In Malham, it began at Strete Gate, which is on Raikes Road, heading some 8 kilometres over Malham Moor to what was a monastic grange at Kilnsey. It is estimated that the monks at Fountains Abbey owned around 150,000 sheep across its Yorkshire estates.

DID YOU KNOW?
Fountains Abbey was founded by thirteen monks in 1132.

That isn't the route's only secret, as the track runs past a Roman marching camp on the moor too. It was reputedly built in the first century AD and lies on a high plateau, making it a perfect place for assembling troops. It covered more than 8 hectares and its entrances were guarded by clavicula, which are curved banks.

Mastiles Lane wasn't the only monastic route in this area; Monk's Road ran from Arncliffe to Malham, again linking up estates and land. On this path is a likely Iron Age/Romano-British settlement at Blue Scar. There's also evidence of a possible prehistoric cairn from earthwork examination.

An Iron Age settlement, situated on a plateau south of Arncliffe by the top of Great Sear, had a small rectangular and one circular chamber contained within two enclosures, and was linked by a sunken road to a Celtic field system.

The Blue Scar Iron Age settlement had rectangular enclosures, west of the sunken road. 'The walls were built of limestone about 5 feet wide at the base and standing 2–3 feet,' the national park says. 'The huts are grouped round a courtyard at the south- east end and have a large stock-yard attached to them. Of the fourteen huts, only two are circular (those in the north-west corner) and one on the east side is approximately a circle. The

remainder are rectangular, about 30 x 12ft. At the north end of the scar there was two main complexes – two conjoined enclosures around 18-metre square.'

Thorns

Around 2 kilometres from Ribblehead, near Gearstones, is a medieval settlement that had ten ancient routes radiating from it, indicating just how important it was for its inhabitants – and owners.

Thorns was first recorded as place of residence in 1189–90 when it was bought by Furness Abbey as part of a vast estate covering this area of the Dales. It ran from Chapel-le-Dale to the top of Whernside, on to Newby Head, and then over to Low Birkwith and Selside. It also went right up to the Lancashire border at Bowland and covered most of Ingleborough.

The monks established a sophisticated set-up with four large estates at Southerscales, Winterscales, Selseth (now Selside) and Birkwith and a hierarchy of settlements known as lodges. Newby was its headquarters and Colt Park, near Ribblehead, as the name suggests, was a stud farm.

Whilst Thorns wasn't a lodge, it wasn't at the bottom of this tiered system and at the time of the Dissolution, there were six tenements, five of which have been uncovered by archaeologist and historian Dr David Johnson and a number of volunteers. He, alongside the Stories in Stone project, have ensured that Thorns is incredibly well preserved and documented.

Thorns is an enchanting place.

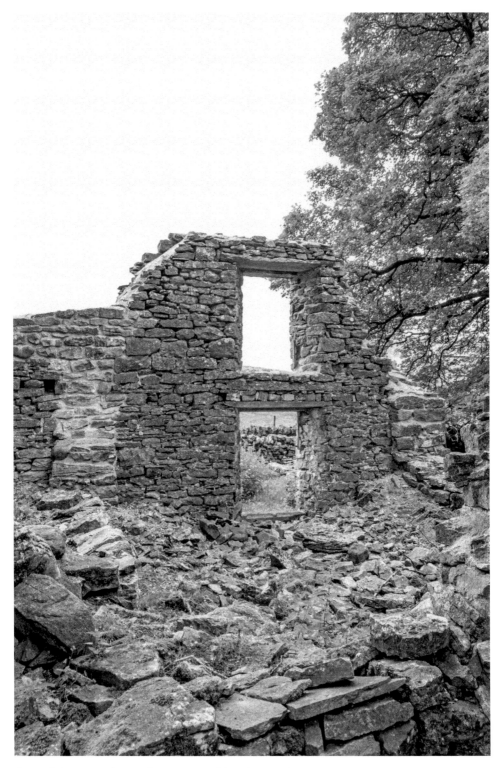

Some of the restoration work to preserve this unique settlement.

One of ten ancient routes radiating from Thorns.

The packhorse bridge at Thorns Gill would have taken one of the many routes from the settlement.

Over the next 300 years, the number of people living there decreased and records show that whilst in 1841 there were twenty-one inhabitants, forty years later there were just two brothers. In 1891, there was one uninhabited dwelling.

Thorns had passed through various dukedoms since the Dissolution until the whole manor was bought by the Farrer family in 1810. They stayed connected to the area until 1953, when they had to sell it because of death duties.

At the site now are visible remains of three houses, and three more in the earthwork alongside crumbling barns and a communal out office (imagine using that in a Dales winter!). It is an eerie place to visit, quiet only for the occasional bleat of sheep and jackdaw call. The fact it is hidden from view by huge sycamore trees adds to the mystique.

As Dr David Johnson says: 'I don't know anywhere in the national park where you have something on the scale of Thorns preserved so well in the landscape that has been abandoned.' He is right too.

The 111-kilometre Ribble Way runs through Thorns and that is the best place to view it. To keep the settlement, and all the history it holds for future generations, you must stick to the path and admire it from afar.

DID YOU KNOW?
Just along the Ribble Way is the restored Back Hools Barn. It has been renovated and cleaned out by Stories in Stone, and has apotropaic symbols (designed to keep out witches) etched into the door jambs. It is a fine example of a field barn and its restoration is a fantastic way of connecting and showing visitors farming heritage of this working landscape.

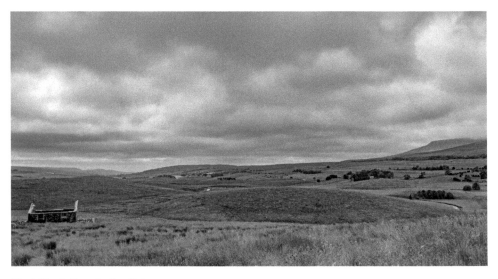

Black Hools Barn in the distance.

A fantastically preserved site.

9. The New Ways

On 1 August in 2016, the Yorkshire Dales National Park officially grew by 417 square kilometres to protect parts of Cumbria in the north, towards Tebay, and a small part of Lancashire in the south. The designation meant it now covered 2,179 square kilometres in total and brought it closer to the Lake District National Park which also added 3 per cent to size.

The new park welcomed in such iconic, but little-visited places, as Great Asby Scar and the northern Howgills, alongside the sweeping Casterton, Middleton, Barbon and Leck fells – and all their wonders hidden beneath ground.

It was a controversial decision as these are areas with their own distinct identity, and the YDNPA knows that it still has work to do. 'The addition of a further 188 square miles does present challenges,' it wrote. 'However, extending the boundaries of these beautiful and internationally iconic areas should provide a boost to rural tourism in the area, supporting rural businesses and potentially adding millions more to the £4 billion already generated by visitors to the national parks each year.

'We will be listening to and learning from the local communities, farmers, landowners and businesses to enable us to develop productive, long-term relationships. Working together, the national park authority is determined to play a leading part in making the most of the wonderful opportunities this decision offers for both the landscape and local economy.'

DID YOU KNOW?
The Westmorland Dales has the highest concentration of limestone pavement outside the Yorkshire Dales.

After lengthy consultation, the north of the park was named the Westmorland Dales. To many this is Cumbria and the introduction of 'Yorkshire' in the title was worrying to some. As a result, the signs to signal the entrance to this area all have Westmorland Dales as the focal point, with Yorkshire Dales and the national park's badge a lot smaller.

The Westmorland Dales has a population of around 3,500 people with Orton the most densely populated village. It also takes in the southbound M6 Tebay services too, seen as the gateway to the Dales.

Gamelands Stone Circle. (Andy Kay / Yorkshire Dales National Park Authority)

Gamelands Stone Circle, Orton

This stone circle, which stands at the base of Knott Scar, around halfway between Orton and Raisbeck, may be a shadow of its former self but is one of the most tranquil places in the new extension area. The thirty-three stones create an oval shape of 44.5 by 37.5 metres and none are higher than 1 metre.

It once held forty-three, but the land was ploughed in the 1860s and the stones pulled to the ground. As a result, most of the stones in the southern arc are missing. All but one is pink granite with the lone exception a single block of limestone. Artefacts on the site have been found dated from between 1800 to 1400 BC.

Great Asby Scar, Great Asby

There may be fantastic limestone pavements in the southern parts of the Dales, but they have a stunning rival in Great Asby Scar. Quite simply, it is one of the finest in the country and is part of a scar that covers around 11 square kilometres. It has rich flora including harts tongue fern, dog's mercury and bloody crane's-bill alongside hawthorn and ash.

It also contains Castle Folds, a Romano-British walled settlement which was used as a summer shelter, called a shiel. It enclosed around half a hectare of land and had roughly twelve stone huts built into the walls.

A survey in 2019/20 by the Westmorland Dales Partnership found 300 potential sites of interest on the Scar – previously they knew of fifty-nine. These included more shieling enclosures, cairns, quarries, possible bell pits associated with early copper mining and

Looking over Sunbiggin Tarn towards the Howgills. (Andy Kay / Yorkshire Dales National Park Authority)

standing stones placed into grykes which appear to have been used as targets for shooting practice.

The Scar is a designated National Nature Reserve and nearby is the wonderful Sunbiggin Tarn.

Fox's Pulpit, Firbank Fell, Sedbergh

George Fox, the founder of the Religious Society of Friends, chose this site on 13 June 1652 to address a crowd – which he estimated to be more than 1,000 – and duly begin the Quaker movement. The place of his preaching, Firbank Fell, is unremarkable but is an obvious place of pilgrimage and solace.

Nearby is Brigflatts, one of the famous Quaker meeting houses dating back to 1675. It welcomes more than 2,000 visitors each year.

Low Borrowbridge, Tebay

The Fort at Low Borrowbridge is sited on what could have been the continuation of a stretch of Roman road that heads north out of Sedbergh. It is close to Salterwath bridge, a stone's throw from the southbound M6 motorway.

According to English Heritage the remains of the site are 'extensive and well-preserved. Partial excavation has shown the monument to contain widespread archaeological deposits which provide valuable information on the date and nature of use of the site.

The monument provides important insight into a wide range of aspects of civilian and military life during the Roman occupation of Britain.'

The fort itself would have been 140 metres by 104 metres and surrounded by a 1.5-metre rampart and multiple ditches. It would have included 'sandstone, limestone and slate walling' according to English Heritage, and there are double ditches 'on the west and south sides with an average width of 7 metres and with faint traces of additional ditches, especially in the south-west corner'. There was a civilian element to the fort too, with a settlement that housed a 'bath house built in two phases and a cemetery, both of which were used during the second to third centuries AD'.

A word of warning: the site is part of a working farm and is not accessible apart from on special days which are advertised in advance. From the road it is possible to see the embankment.

Pendragon Castle, near Kirkby Stephen

Legend says that Pendragon Castle was founded by Uther Pendragon, the father of King Arthur, and that the Romans built a fort here as a stopping-off point between their sites at Bainbridge and Brough.

Evidence suggests otherwise as the present castle dates from the late twelfth century with archaeological digs not suggesting anything to the contrary. It then became part of the Clifford family estate and they received permission to fortify it in 1309 after being granted a licence to crenellate.

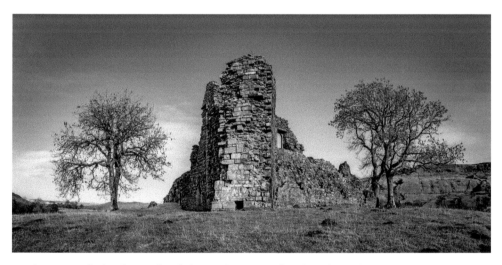

Pendragon Castle. (Andy Kay / Yorkshire Dales National Park Authority)

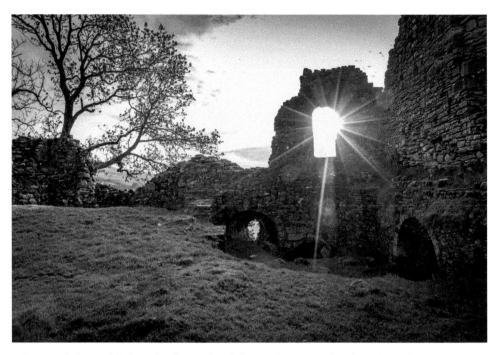

A hauntingly beautiful place. (Andy Kay / Yorkshire Dales National Park Authority)

DID YOU KNOW?
During the medieval period, a licence to crenellate gave the holder permission to fortify his property – and his was usually an order from the king.

It was reputedly set alight by the Scots in 1341, before being rebuilt in the 1360s. It was beset by fire again in 1541, before Lady Anne Clifford restored it in 1660–62. She added stables and a bakehouse to return it to its former glory.

It is now a beautiful and atmospheric ruin sited on private land. Access is allowed but due to its tender nature, care must be taken.

Smardale Gill, near Kirkby Stephen

This nature reserve is in the care of Cumbria Wildlife Trust (CWT) and well worth a visit for the differing birds, flowers, and butterflies, set in the backdrop of the steep gill. It has species-rich grassland which includes bloody crane's-bill, rock-rose, horseshoe vetch, frog, fragrant and greater butterfly orchid as well as woodland that has been present since medieval times. It is also one of only two sites in England where you can see the Scotch argus butterfly, whilst green woodpeckers, treecreepers, ravens and sparrowhawks are resident all-year round.

Smardale Gill. (Andy Kay / Yorkshire Dales National Park Authority)

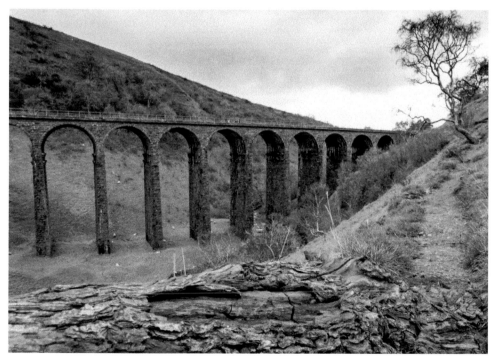

The Grade II listed viaduct which has been restored by the Northern Viaduct Trust. (Andy Kay / Yorkshire Dales National Park Authority)

The reserve has 6 kilometres of level walking and, until recently, you could walk across the Grade II listed viaduct and see the views, although at the time of writing it was closed due to safety concerns. It is around 27 metres high and carried coke to the iron and steel furnaces in West Cumberland. Built in 1861 by Sir Thomas Bouch as part of the South Durham & Lancashire Union Railway, it was closed in 1962, and then handed over to CWT in 1992 to become part of the reserve.

Smardale covers 49 hectares and consists of three separate nature reserves that occupy an 8-kilometre section of a railway line that once ran from Tebay to Darlington. There is public parking available after taking the Smardale turning from the A685 between Ravenstonedale and Kirkby Stephen.